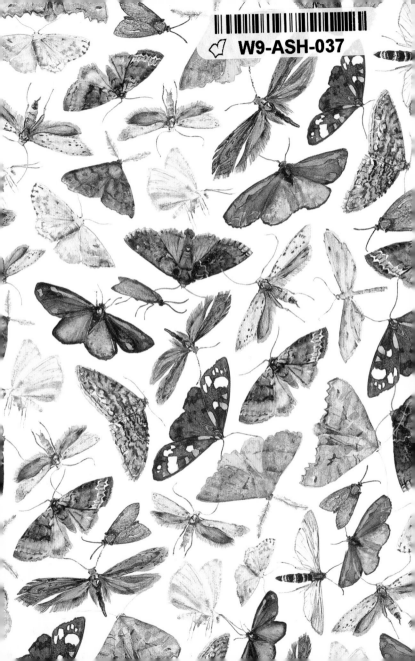

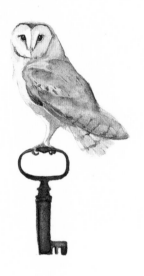

ex libris

THIS BOOK BELONGS TO:

the
lost
spells

ROBERT MACFARLANE

JACKIE MORRIS

ANANSI

for Jessica

This is a book of spells to be spoken aloud. It tells its stories and sings its songs in paint and word. Here you will find incantations and summoning charms, spells that protect and spells that protest, tongue-twisters, blessings, lullabies and psalms. Here you might swoop with a swallow, follow a seal through the sea or sky-race with swifts. Here you can listen with owl ears and watch with the eyes of an oak. Here a fox might witch into your mind, or flocks of moths may lift from the page to fill the air.

Loss is the tune of our age, hard to miss and hard to bear. Creatures, places and words disappear, day after day, year on year. But there has always been singing in dark times – and wonder is needed now more than ever. 'To enchant' means both to make magic and to sing out. So let these spells ring far and wide; speak their words and seek their art, let the wild world into your eyes, your voice, your heart.

red fox

I am Red Fox – how do you see me?

A bloom of rust
 at your vision's edge,
The shadow that slips
 through a hole in the hedge,
My two green eyes
 in your headlights' rush,
A scatter of feathers,
 the tip of a brush.

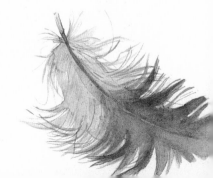

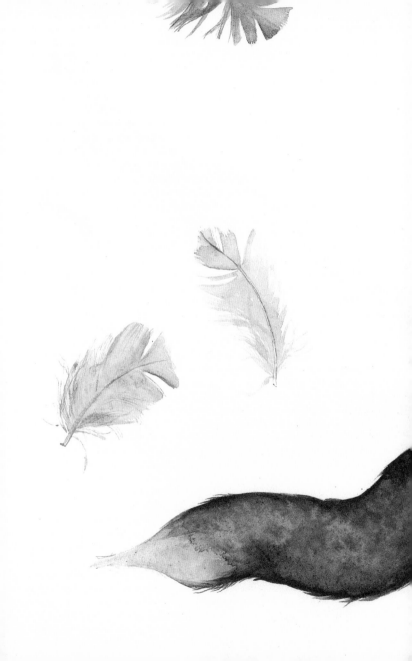

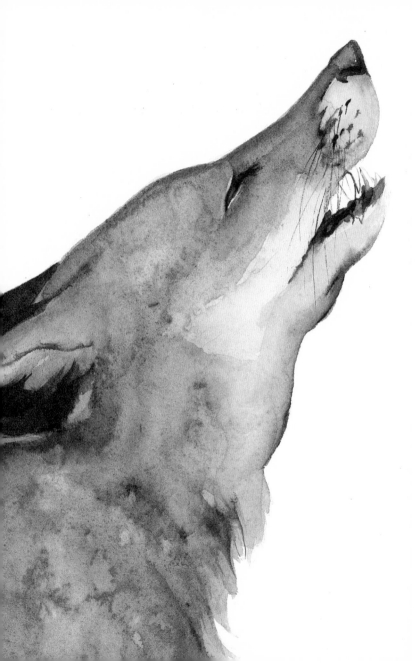

I am Red Fox – when do you hear me?

A scream in the night
 that stops you dead;
Dark torn from dark,
 a bolt through the head,
My sorrowful love-song
 howled to my lover,
My trash-can clatter
 from twilight's cover.

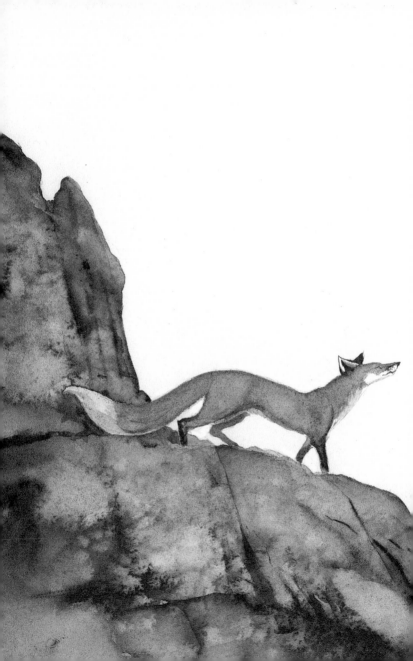

I am Red Fox – where do you find me?

In copse and spinney,
 ginnel and alley,
For I haunt city
 as I haunt valley,
Climbing the fell-side,
 crossing the pass,
Walking the high street,
 bold as brass.

I am Red Fox – what do you call me?

Shifter of shapes
 and garbage-raider,
Bearer of fire
 and space-invader,
Taker of risks
 and riddle-maker,
Messenger, trickster,
 curfew-breaker.

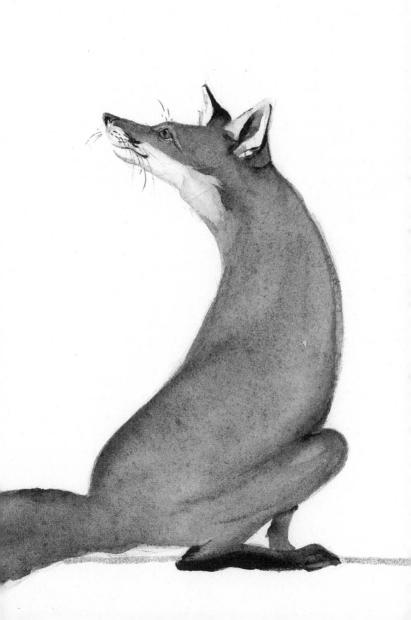

I am Red Fox – why do you need me?

I am your double,
 your ghost, your other,
The spirit of wild,
 the spirit of weather,
Red is my fur and
 red is my art,
And red is the blood
 of your animal heart.

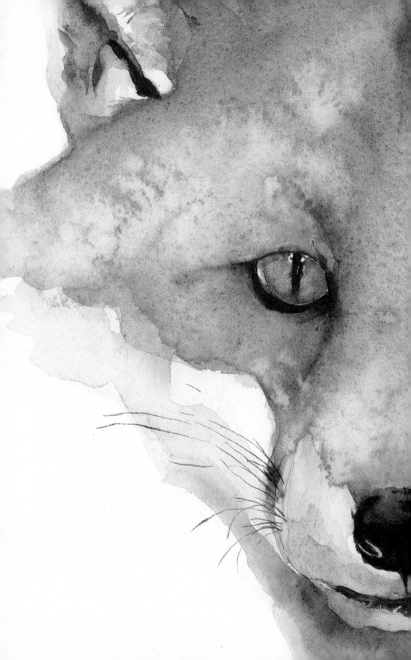

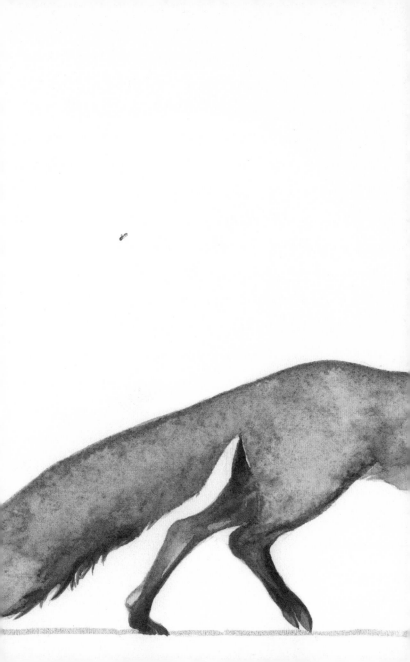

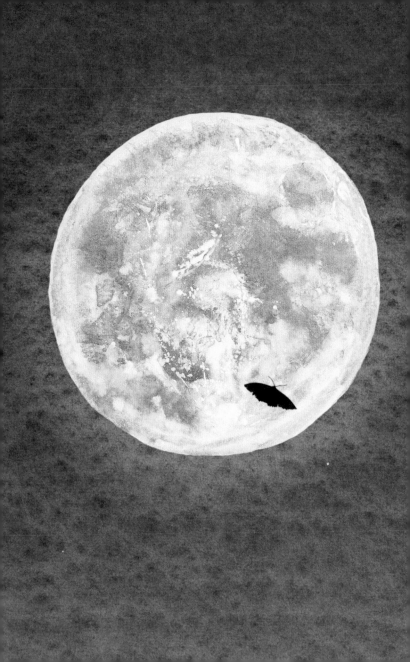

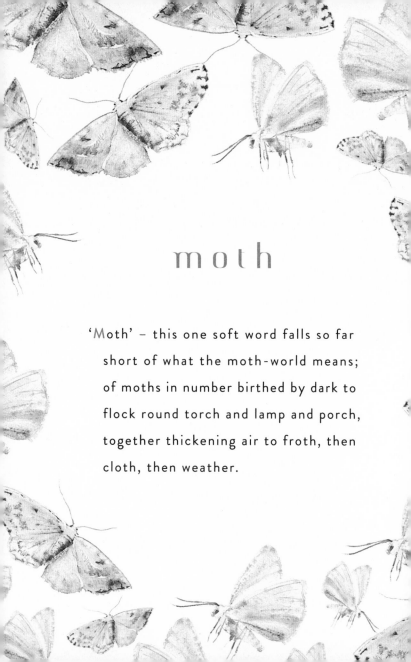

moth

'Moth' – this one soft word falls so far
short of what the moth-world means;
of moths in number birthed by dark to
flock round torch and lamp and porch,
together thickening air to froth, then
cloth, then weather.

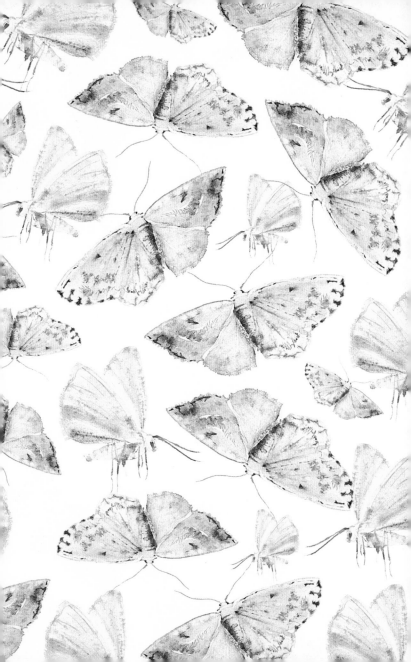

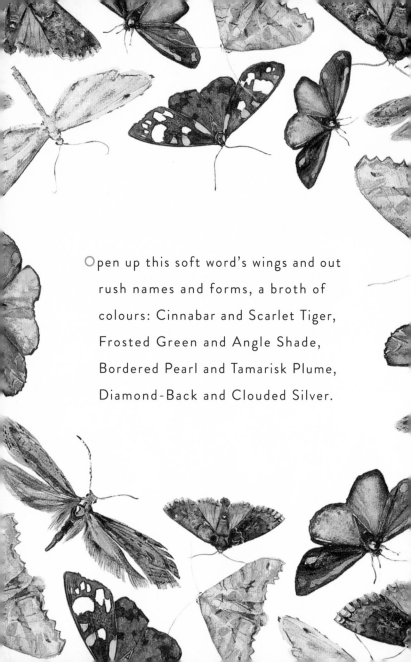

Open up this soft word's wings and out
rush names and forms, a broth of
colours: Cinnabar and Scarlet Tiger,
Frosted Green and Angle Shade,
Bordered Pearl and Tamarisk Plume,
Diamond-Back and Clouded Silver.

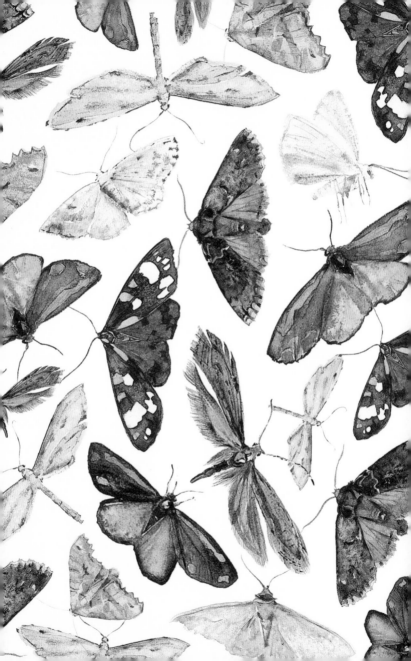

Thinner and thinner wears the cloth,

however; moths pass out of sight,

beyond belief, their absence briefly

noted, if at all, as distant memory,

half-forgotten grief.

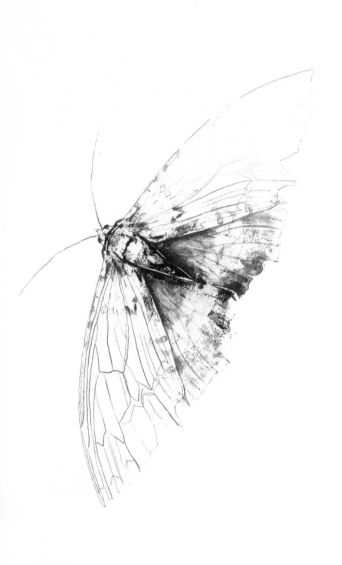

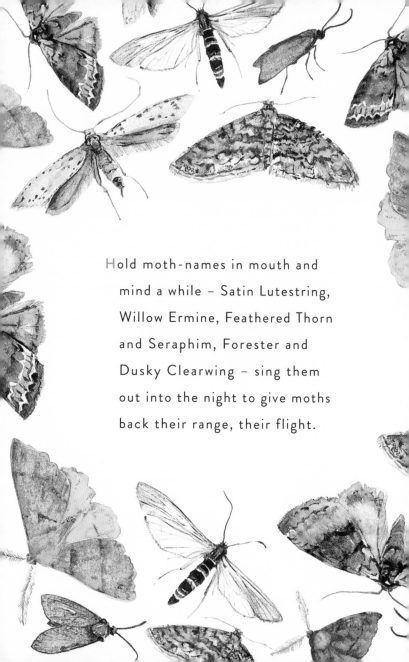

Hold moth-names in mouth and
 mind a while – Satin Lutestring,
 Willow Ermine, Feathered Thorn
 and Seraphim, Forester and
 Dusky Clearwing – sing them
 out into the night to give moths
 back their range, their flight.

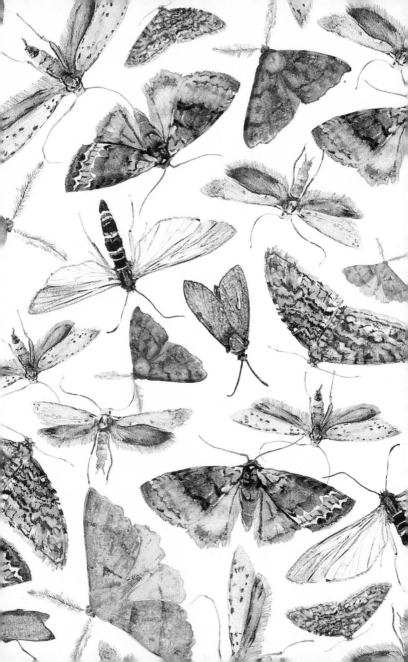

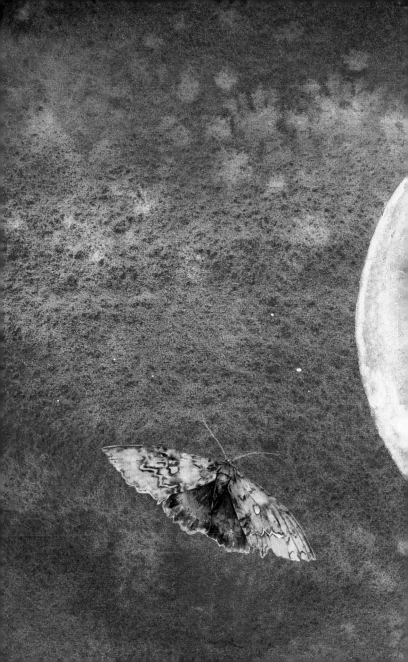

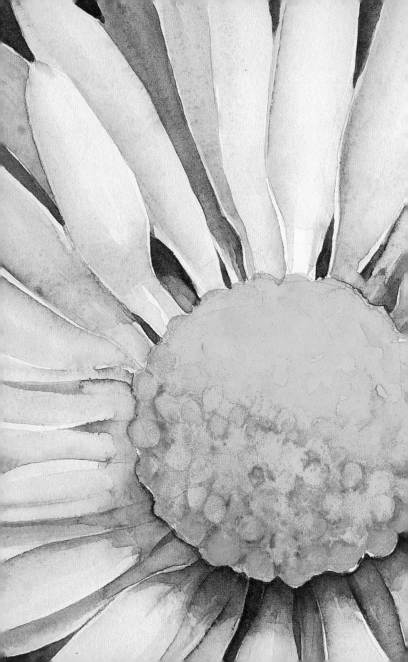

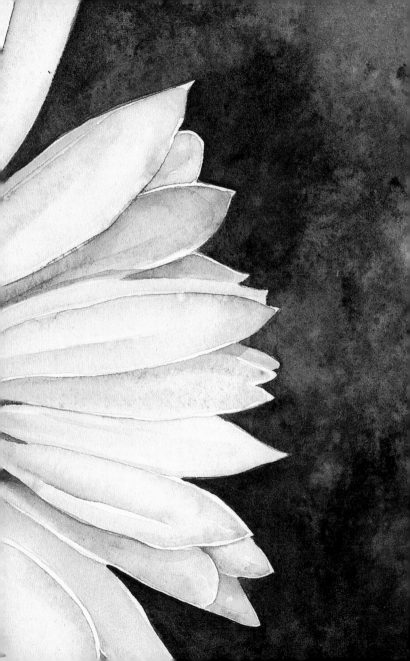

daisy

Daisy, the day's eye,
　　ten-a-penny chain-maker,

Acre upon acre of tiny suns
　　turned skyward;

I would braid you into
　　bracelet and coronet,
　　necklace and ring;

Sing of you as jewels
　　of the meadow,
　　gems of the lawn,

Yawning open every dawn,
　　closing up each dusk;
　　Daisy, the day's eye.

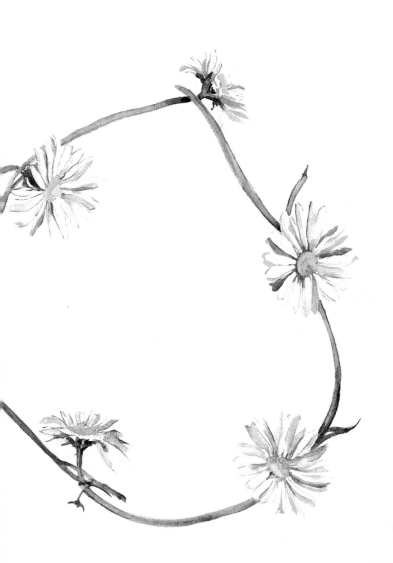

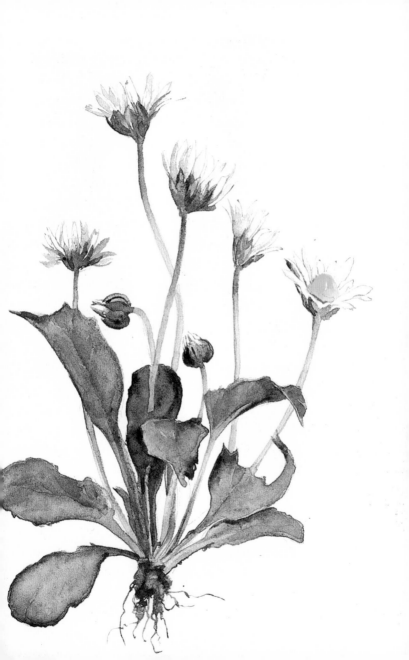

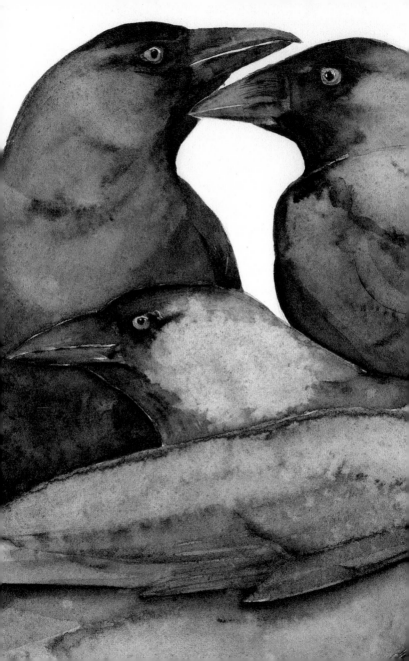

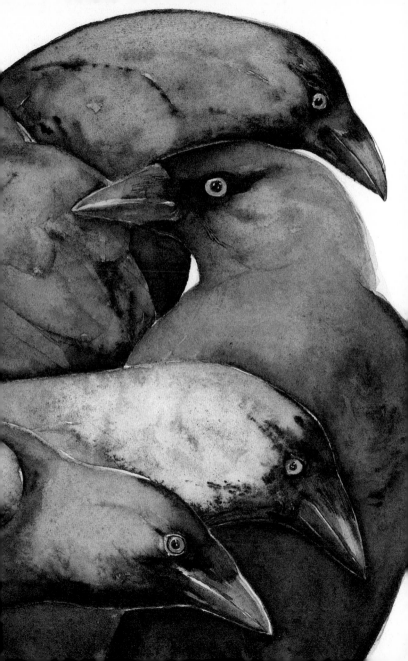

jackdaw

J-J-J-J-Jackdaw,
 circling the back door,
 showing off your knack for
 letting rip that high caw,
 cutting like a hacksaw
 through the evening's calm core,
 giving it the jaw-jaw!

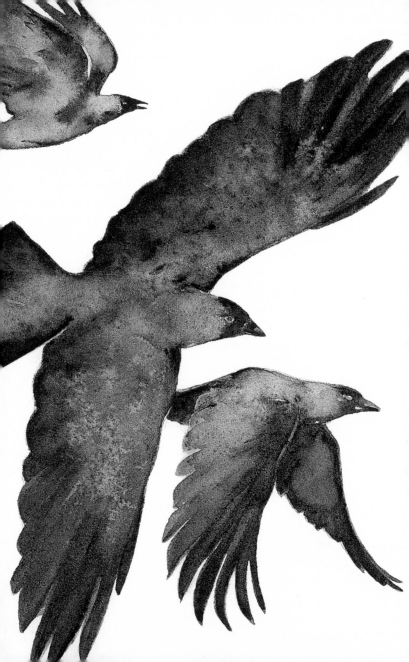

Always with the comeback,
 coal-black crackerjack,
 joker of the haystack,
 ready with the wisecrack,
 giving it the backchat!

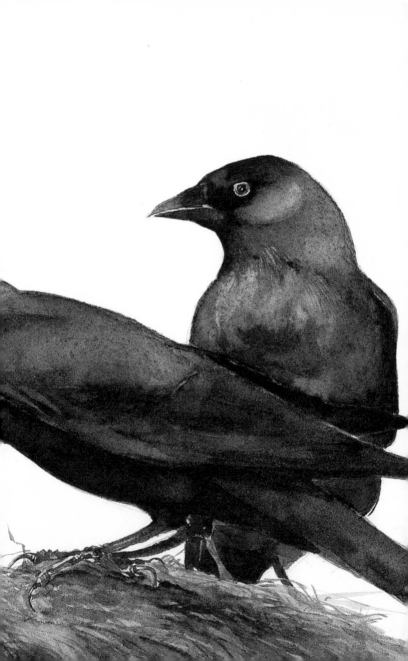

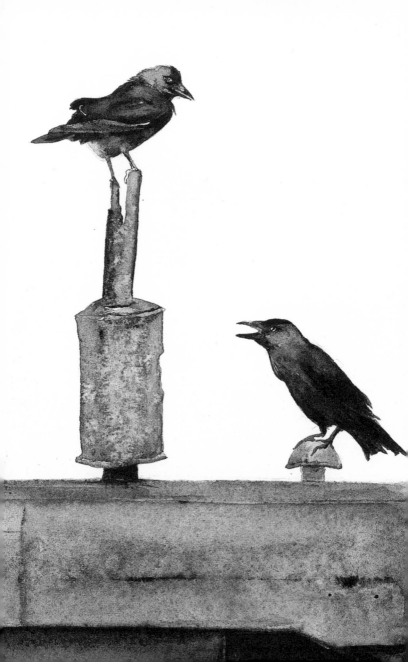

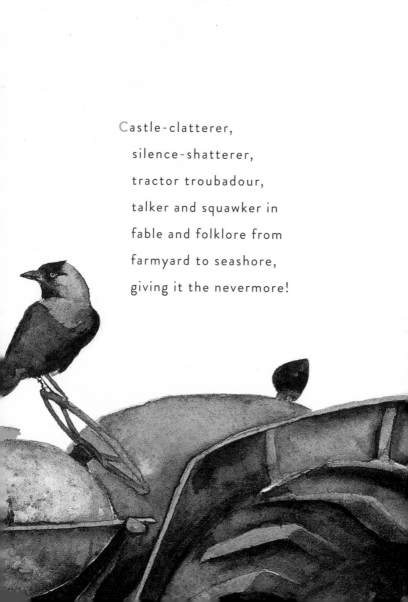

Castle-clatterer,

silence-shatterer,

tractor troubadour,

talker and squawker in

fable and folklore from

farmyard to seashore,

giving it the nevermore!

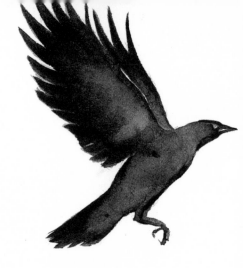

King of the chimney-stack,
 the belfry bivouac,
 bright-eyed steeplejack,
 from church-tower to tarmac,
 giving it the snicker-snack!

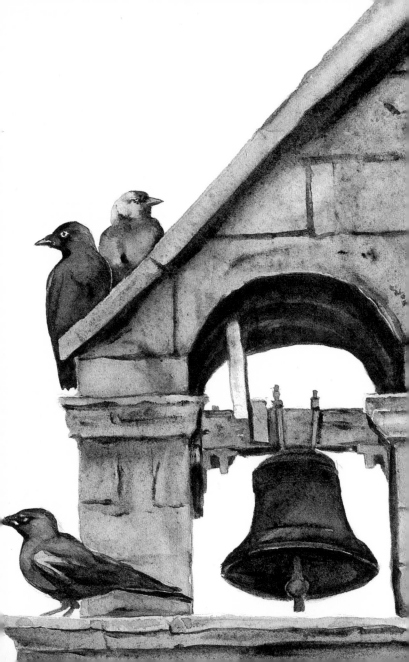

Don't call her Crow
 or Rook or Raven,
 for she is Jackdaw,
 grey-headed outlaw,
 fighting the class war,
 dipping down on quick wings
 to hijack a wedding ring or
 ransack a knick-knack or
 snatch up a gimcrack
 while giving it the guffaw!

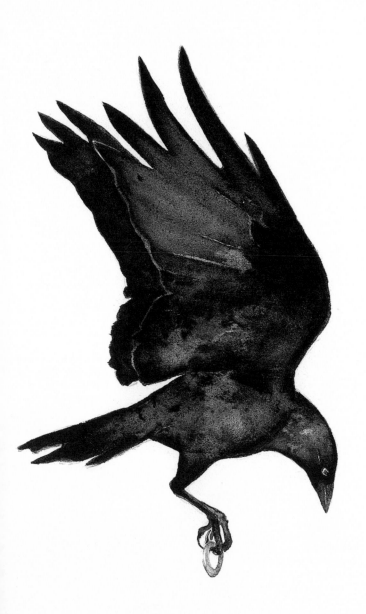

As dusk darkens Jackdaws gather
to shake out feathers,
jam-pack the brickwork,
pick through the tidewrack,
nestle in the bedstraw,
duck through the trapdoor,
fossick on the barn floor,
bushwhack the ivy,
gossip in the sycamore,
this close to sleep
still giving it the click-clack!

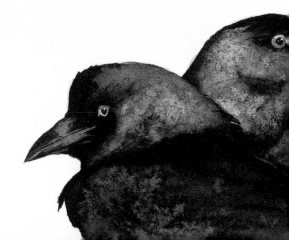

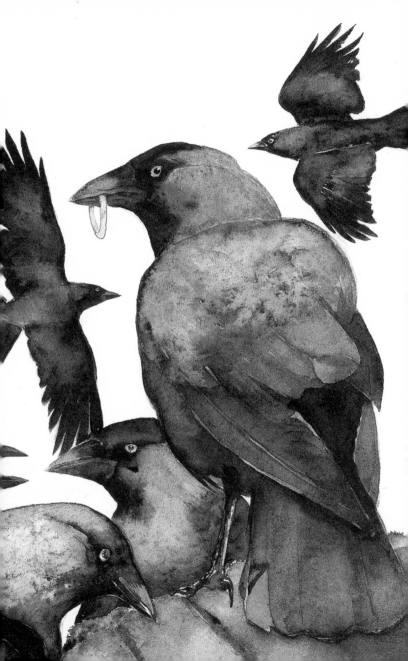

Why not learn

 the Jackdaw beatbox,

 the Jackdaw seesaw,

 the Jackdaw uproar,

 the zigzag riprap

 Jackdaw soundtrack,

 pulling on the ripcord

 furthermore and evermore,

 giving it the chainsaw,

 the whipcrack, the hee-haw,

 giving it the wherefore, the whyfore,

 the therefore, the J-J-J-J-Jackdaw!

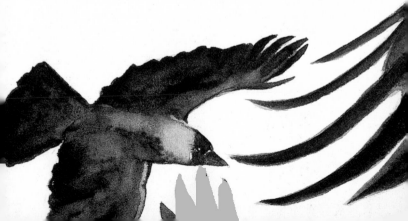

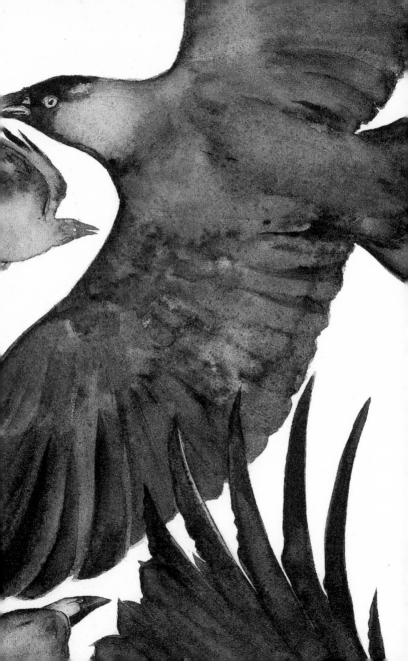

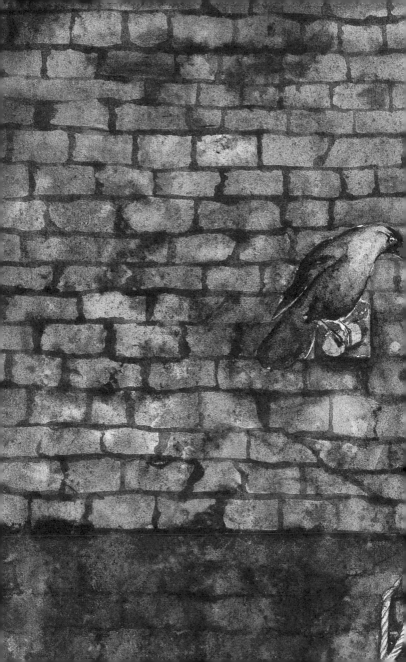

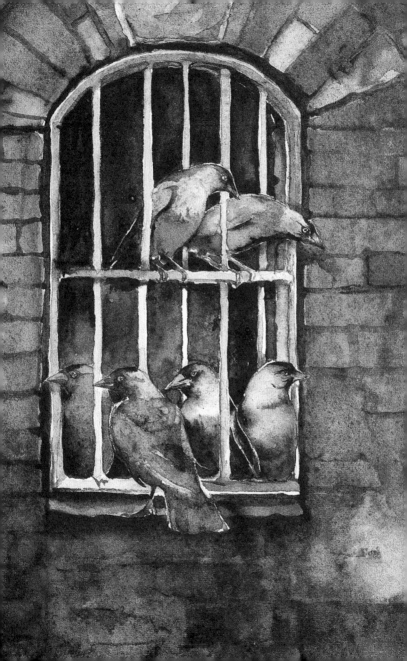

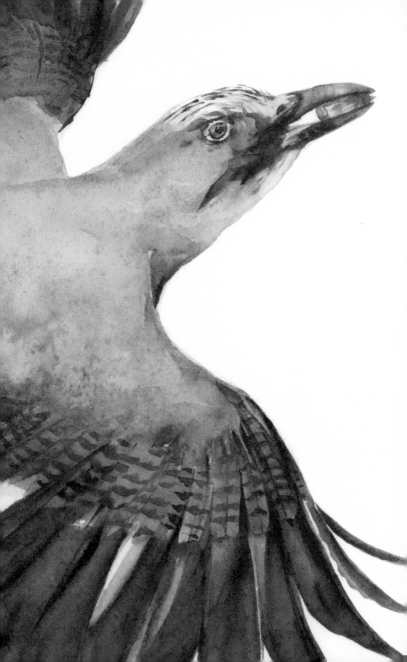

jay

Jay, Jay, plant me an acorn.

I will plant you a thousand acorns.

Acorn, acorn, grow me an oak.

I will grow you an oak that will live for a thousand years.

Year, year, fledge me a Jay.

I will fledge you a Jay that will plant you a thousand acorns that will each grow a thousand oaks that will each live a thousand years that will each fledge a bright-backed, blue-winged, forest-making Jay.

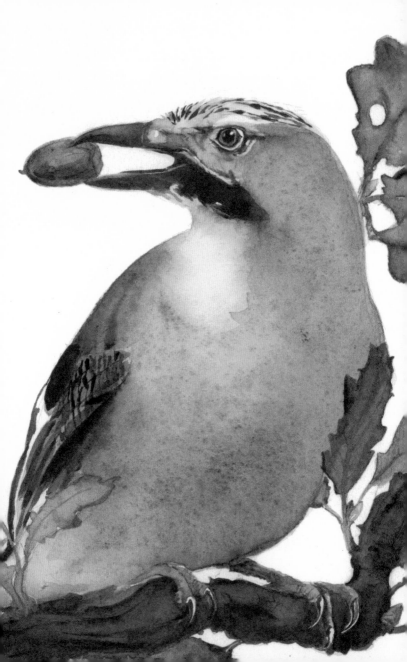

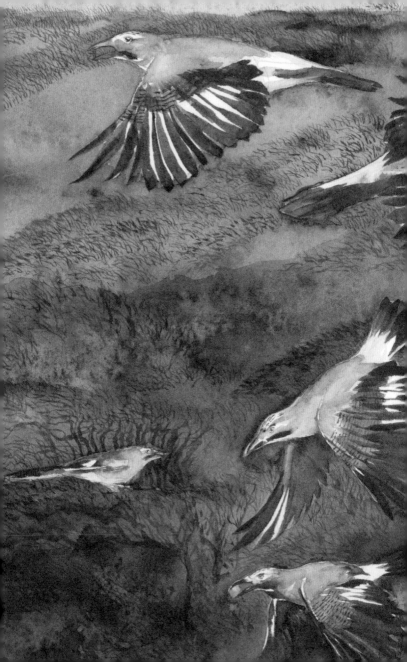

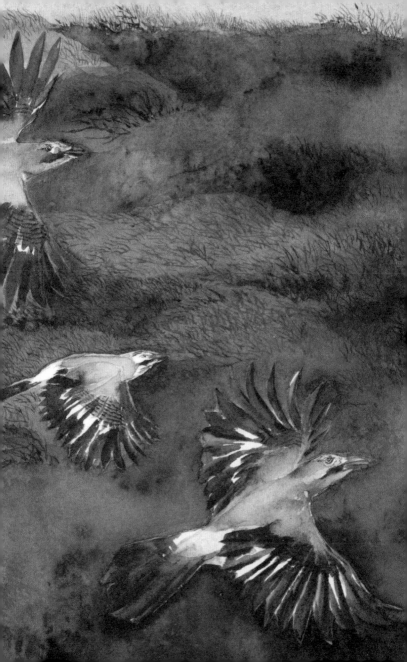

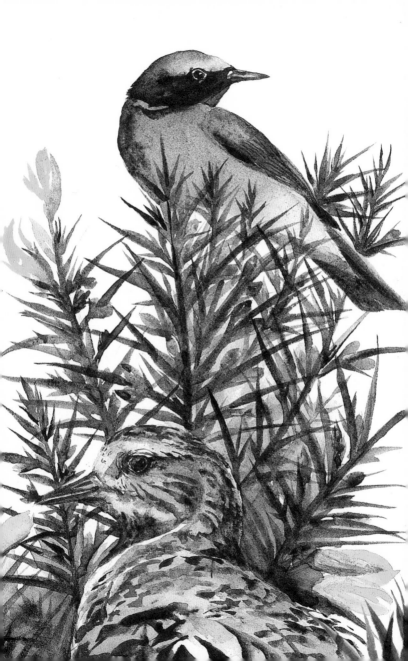

gorse

Good luck trying to force your way through
 Gorse! Better setting out across
a field of spears, a lake of pikes, a sky of
 hawks, a hundred winters;
better getting dealt a thousand scratches
 by a million splinters!

Out of crags and hedges, cliffs and ledges,
 Gorse jags, spikes, crackles; raises
hackles, speaks sharply: *Keep Out! Stay
 Back! Get Off My Land!*

Room is made by Gorse, though – space is
 braced for redstart, rabbit,
wheatear, plover; quiet life is harboured in
 its criss-cross places.

See into Gorse; get past its guard and pick
 a path towards its well-defended
heart, the secrets kept within its limits.

Each of us is partly made of Gorse, of
 course; prickly, cussed, hard to parse
and tough to handle, all helter-skelter
 points and angles – but only ever really
seeking love and giving shelter.

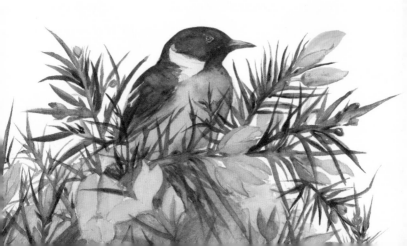

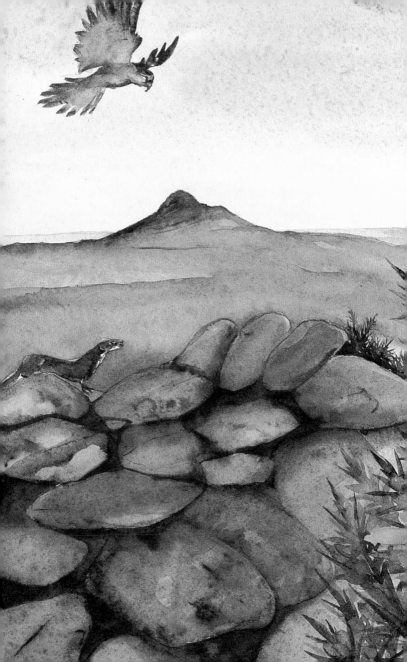

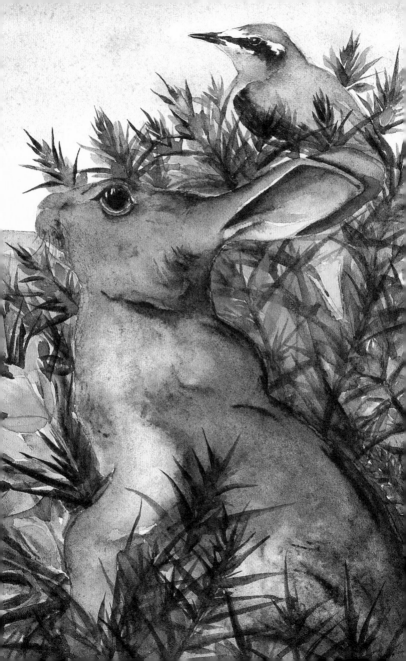

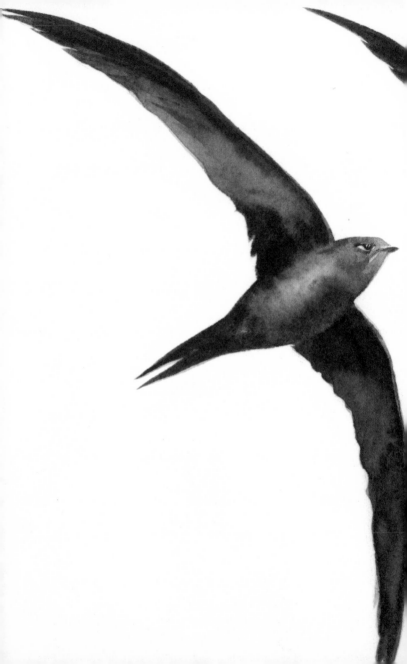

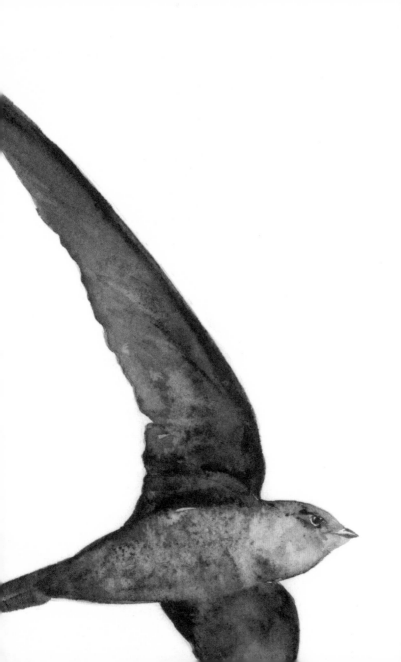

swifts

Spin, world, spin!
 Swifts are here again,
 shredding the sky in
 their hooligan gangs;
 those handbrake-turners,
 those wheelie-pullers,
 those firers-up of
 the afterburners,
 so –

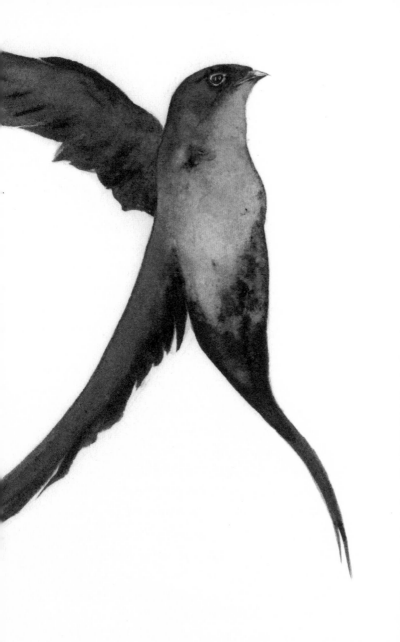

Whirl, birds, whirl!
 You havoc-wreakers,
 thrill-seekers, you
 gung-ho joy-bringers,
 spring-harbingers,
 you drifting, gliding
 sleep-on-the-wingers,
 so –

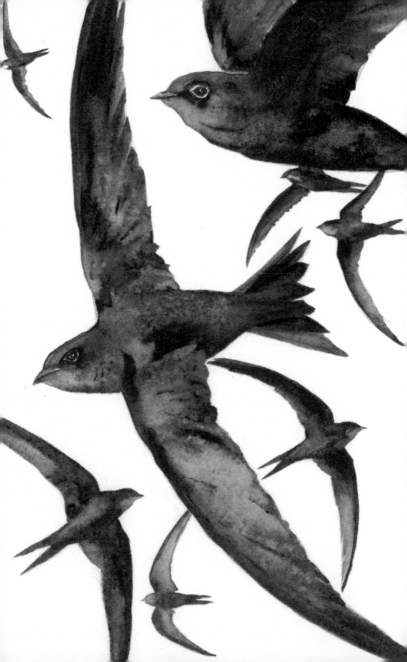

Imagine, now, imagine!
Just how far and fast
these Swifts have
flown to be here;
the deserts crossed
non-stop, the seas
traversed, the mountain
ranges spanned,
so –

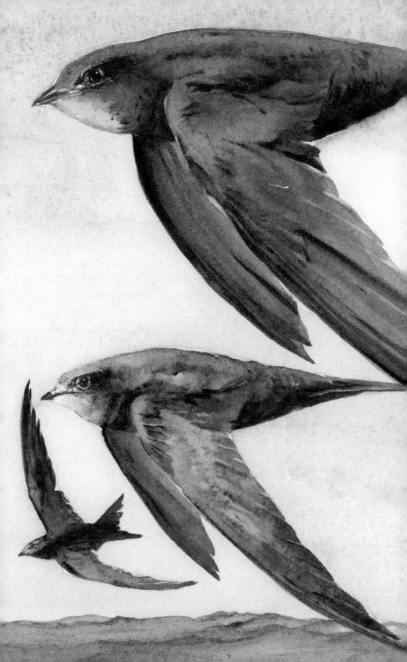

Fly, heart, fly!
　Follow Swifts on their
　screaming tours to
　flicker far out over ocean,
　hunt a storm-cell's
　shifting edge or pierce
　a cloud's slow-motion,
　so –

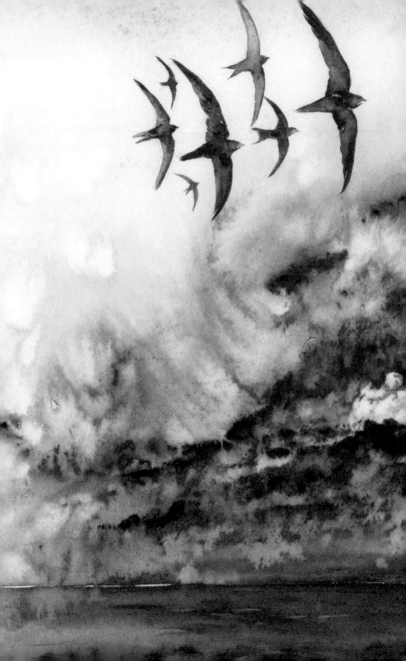

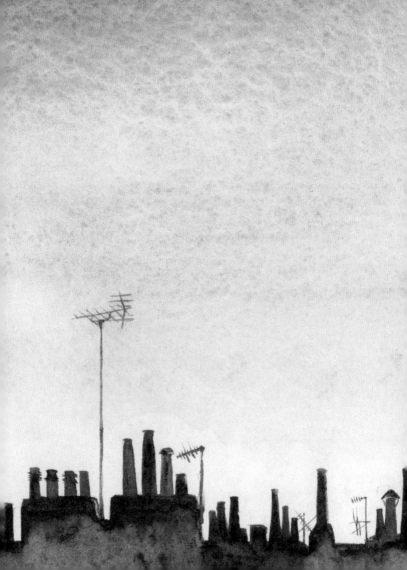

Think, now, think!
 If one year Swifts
 did not appear:
 the sky unriven,
 rooftops silent, all
 the watchers waiting,
 hoping for a gift
 that stays ungiven,
 so –

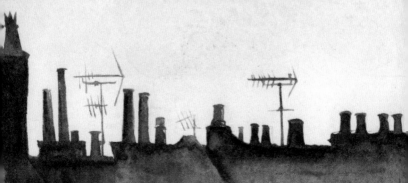

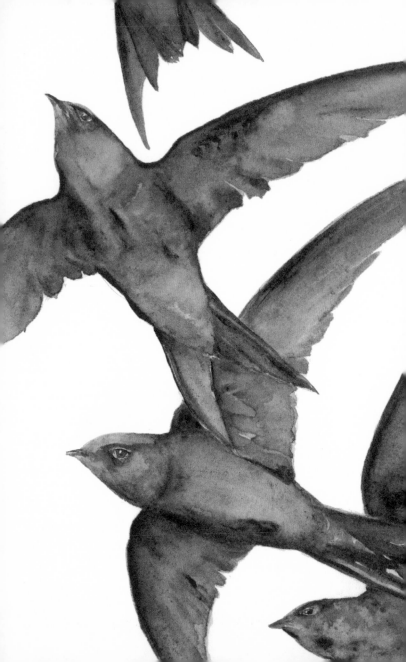

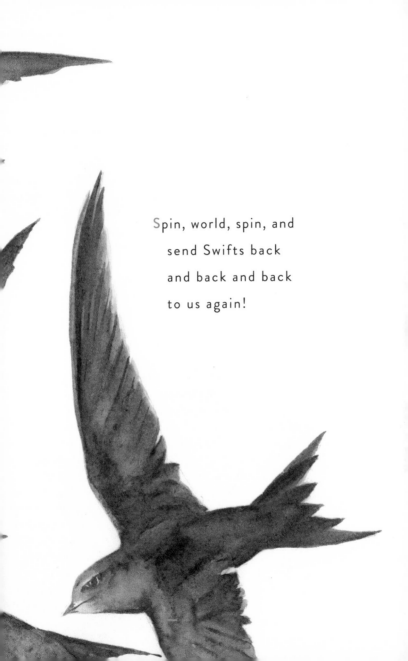

Spin, world, spin, and
send Swifts back
and back and back
to us again!

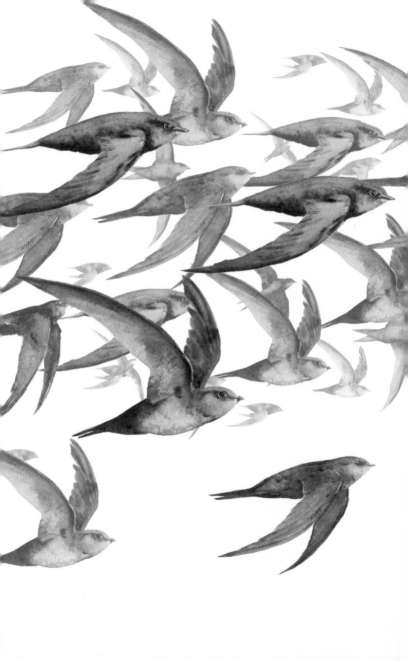

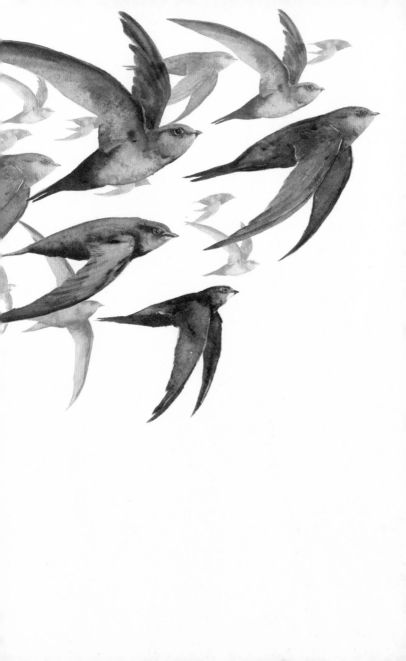

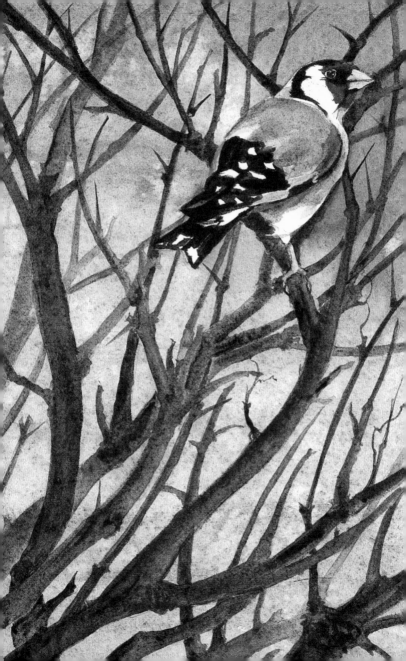

goldfinch

God knows the world needs all
 the good it can get right now –

Out in the gardens and fields,
 Goldfinches are gilding the land for free,

Leaving little gifts of light:
 a gleam for the teasel,
 a glint for the tree.

Did you hear their high scattered song,
 their bright wings' flitter,

Falling around you as flecks,
 as grains, as glitter?

Imagine the loss of their lustre,
 the lack of their sheen:

No more shimmer,
 a worrying absence of gilt.

Charm on, Goldfinch, charm on –

Heaven help us when
 all your gold is gone.

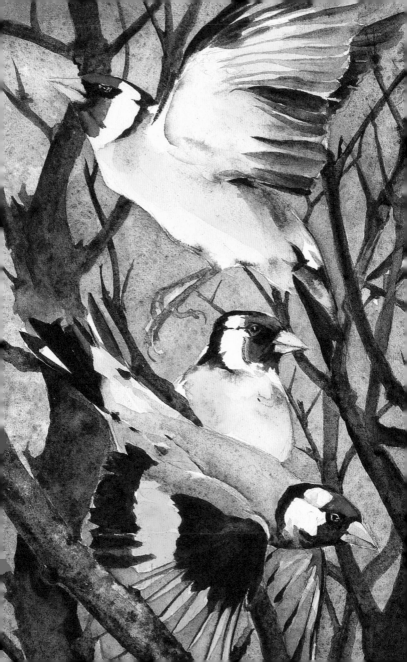

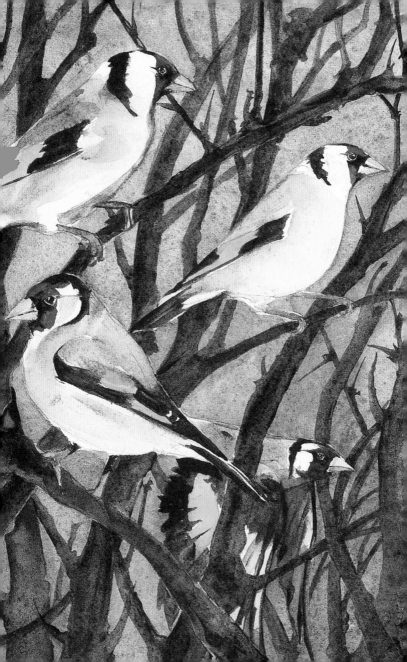

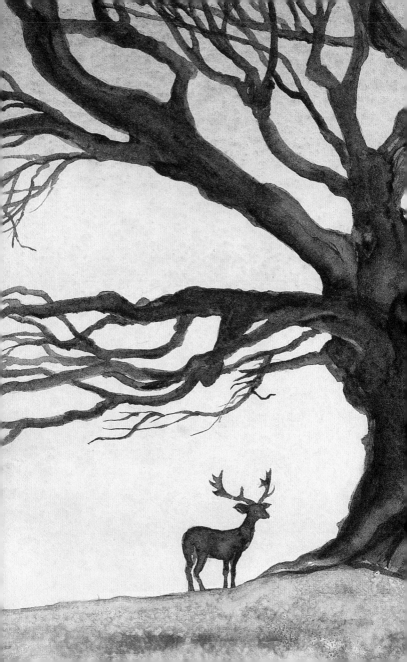

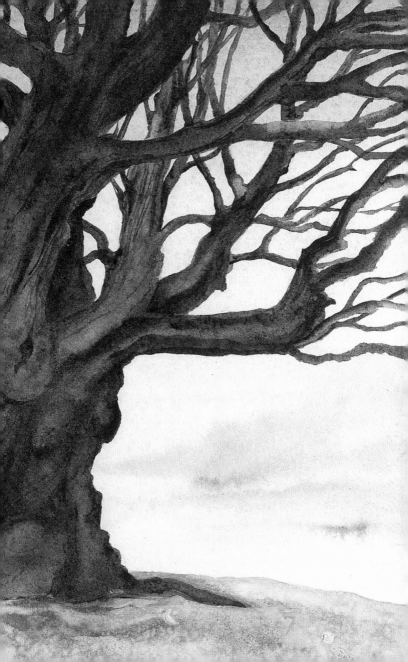

oak

Out on the hill, old Oak still stands:
stag-headed, fire-struck, bare-crowned,
stubbornly holding its ground.

Poplar is the whispering tree,
Rowan is the sheltering tree,
Willow is the weeping tree –
and Oak is the waiting tree.

Three hundred years to grow,
three hundred more to thrive,
three hundred years to die –
nine hundred years alive.

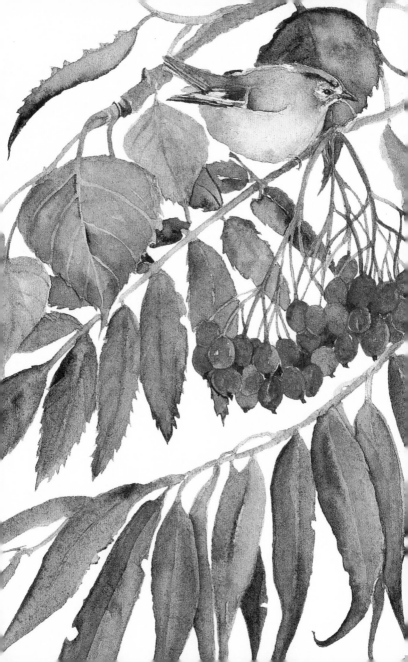

Ancient Oak hears with ancient ears,
sees with ancient eyes; the snow
of another winter, the glow of a
new sunrise.

Birch is the watching tree,
Cherry is the giving tree,
Ash is the burning tree –
and Oak is the waiting tree.

Three hundred years to grow,
three hundred more to thrive,
three hundred years to die –
nine hundred years alive.

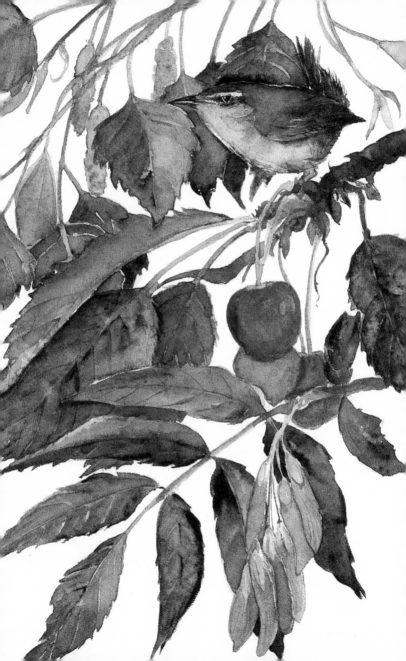

Knot shows through silver grain,
silver grain through bark;
but each fresh spring brings
oak-green leaves again.

Holly is the witching tree,
Beech is the writing tree,
Elder is the quickening tree –
and Oak is the waiting tree.

Three hundred years to grow,
three hundred more to thrive,
three hundred years to die –
nine hundred years alive.

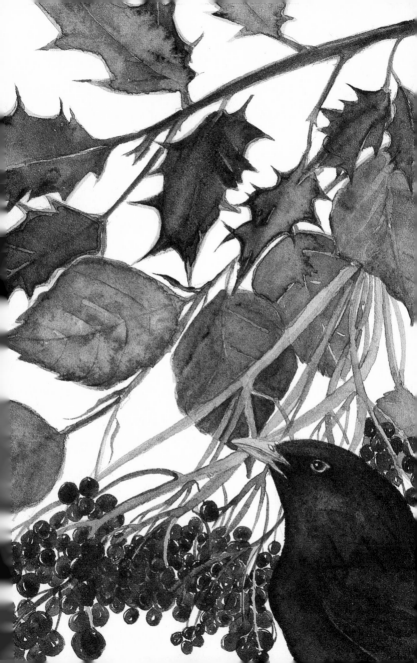

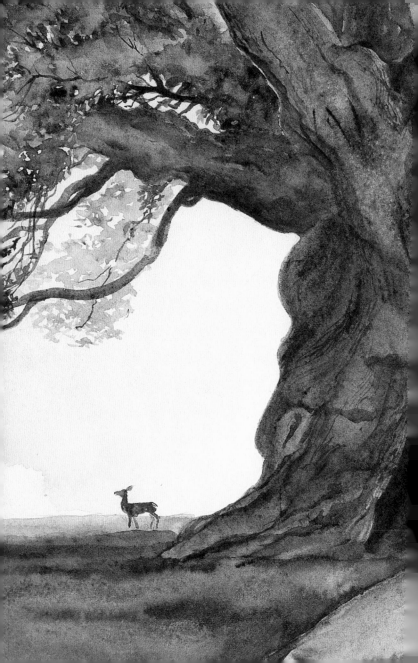

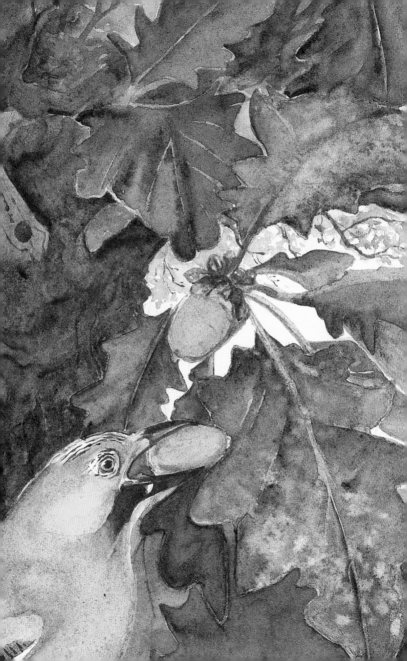

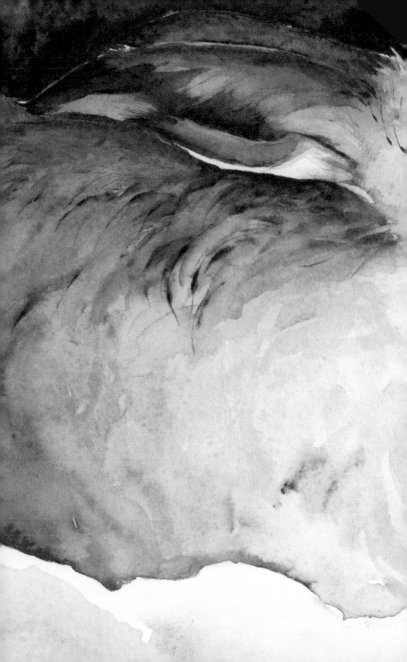

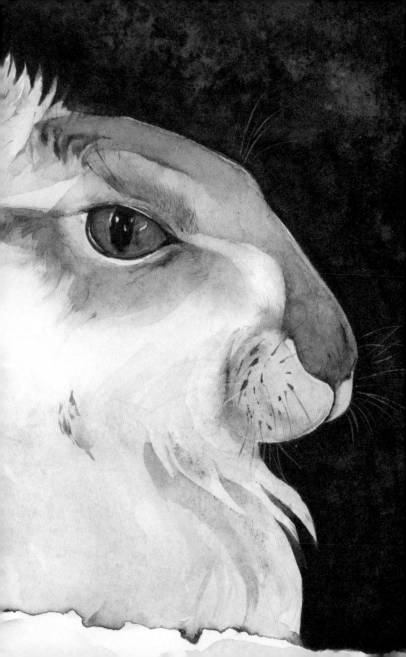

snow hare

Snow Hare whitens as the
 year turns dark –
 By the Cairn of the Wolf,
 in the Glen of the Lark,

Night grows stronger, sleet falls
 sharp on crag and moor –
 By the Burn of the Deer,
 on the Eagle's Tor,

Out on the hill, Hare hunkers
 under hag, hides in heather –
 By the Loch of the Buzzard,
 at the Pass of the Weather.

Wears the cold, vanishes into
 spindrift, hail, blizzard's flight.

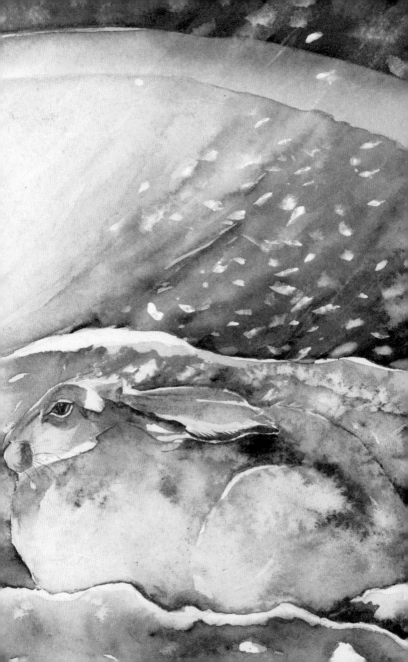

Hare, walking, is graceless;
all long-limbed levers –
By the Salmon River,
on the Road of Reavers,

Awkward pistons, steam-powered
shunts and sudden shocks –
By the Ford of the Pines,
in the Hollow of the Fox,

Running Hare, though, flows through
snow like water over stone –
By the Cliff of the Kite,
at the Peak of the Rowan.

Each long line of tracks a row
of inkwells in the white.

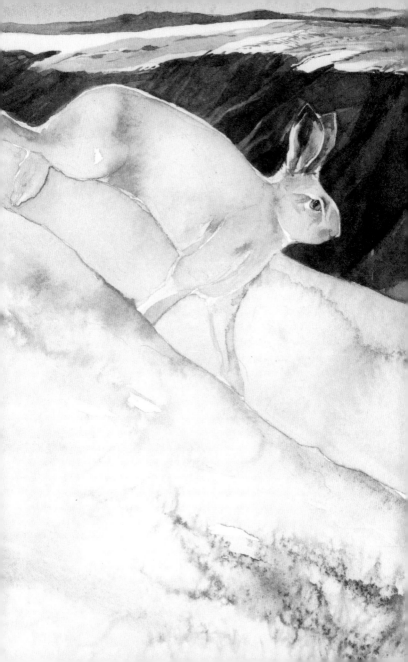

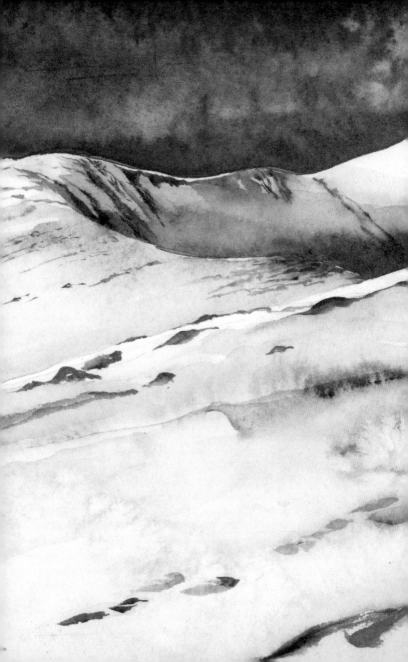

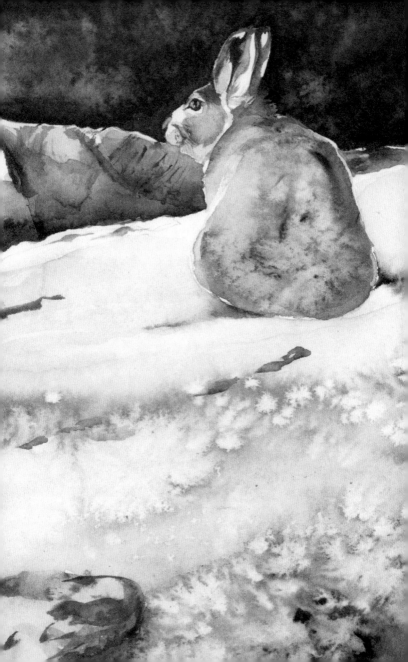

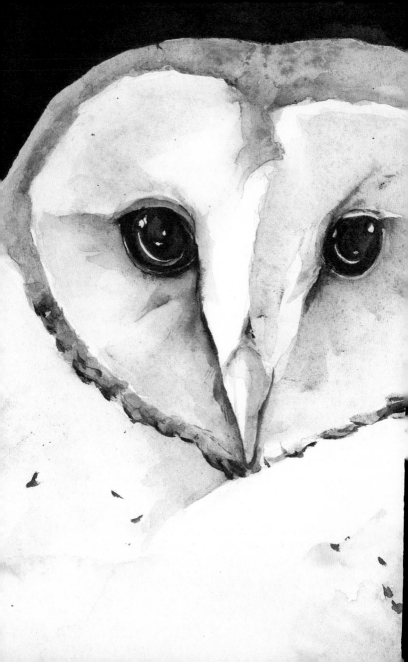

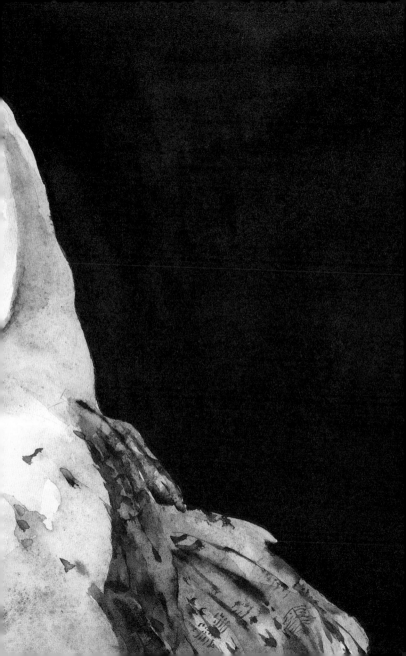

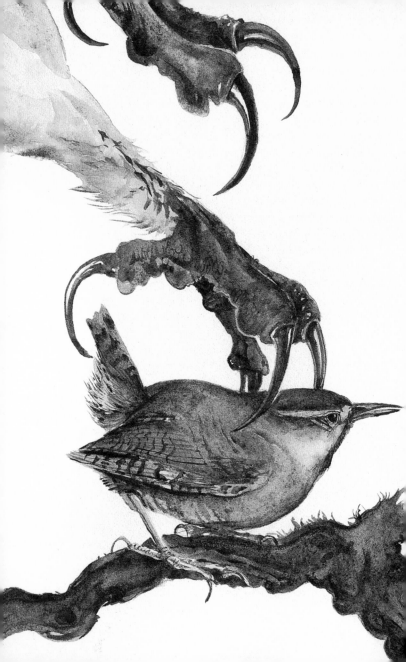

barn owl

Below Barn Owl spreads silence;

All sound crouches to ground,

Runs for cover, huddles down.

Noise is what Owl hunts,
 drops on, stops dead.

Over rushes, across marshes,

Owl hushes –

Will you listen with Owl ears

for a while?

Let the wild world's whispers

call you in?

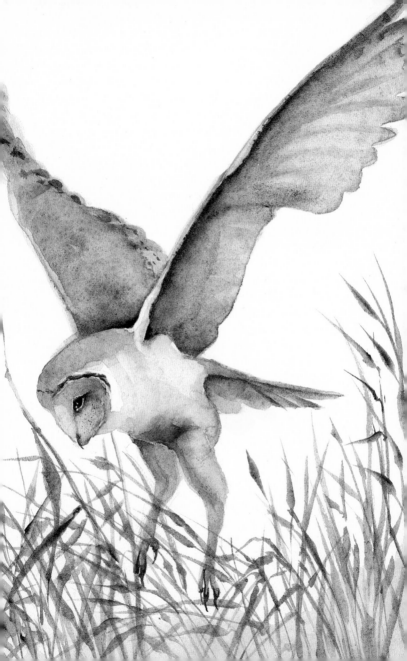

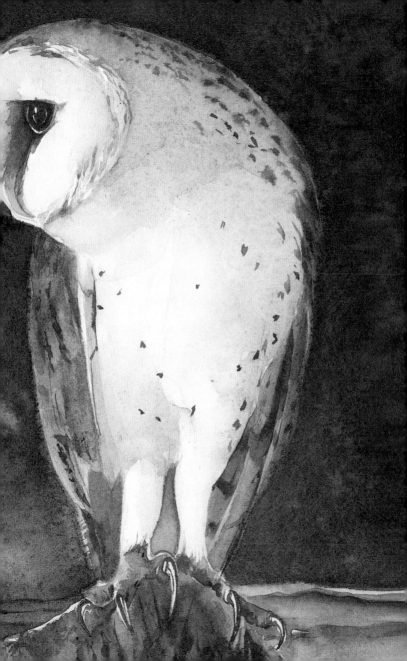

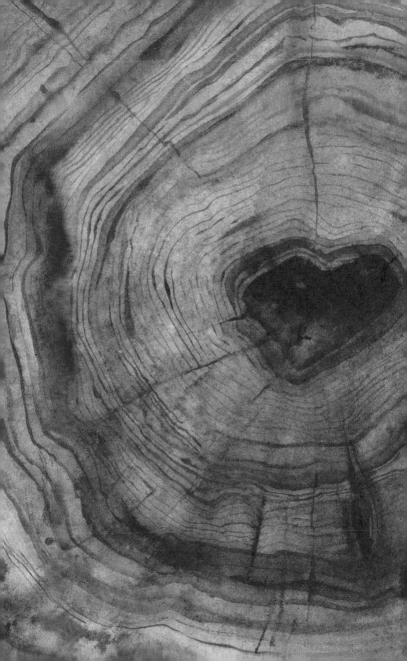

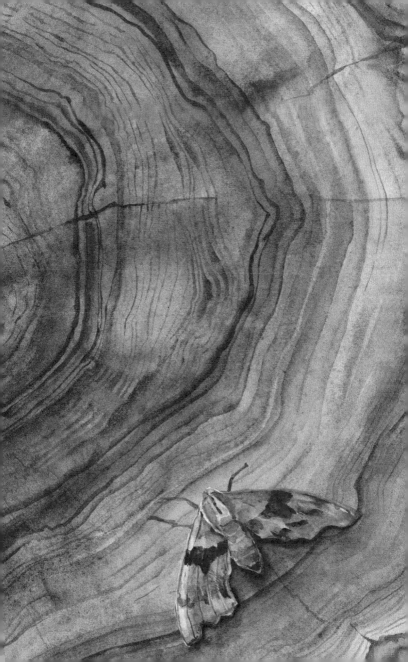

heartwood

Would you hew me to the heartwood, cutter?
Would you leave me open-hearted?

Put an ear to my bark, hear my sap's mutter,
Mark my heartwood's beat, my leaves' flutter.

Would you turn me to timber, cutter?
Leave me nothing but a heap of logs,
 a pile of brash?

I am a world, cutter, I am a maker of life –
Drinker of rain, breaker of rocks, caster
 of shade, eater of sun,

I am timekeeper, breath-giver, deep-thinker;`
I am a city of butterflies, a country of creatures.

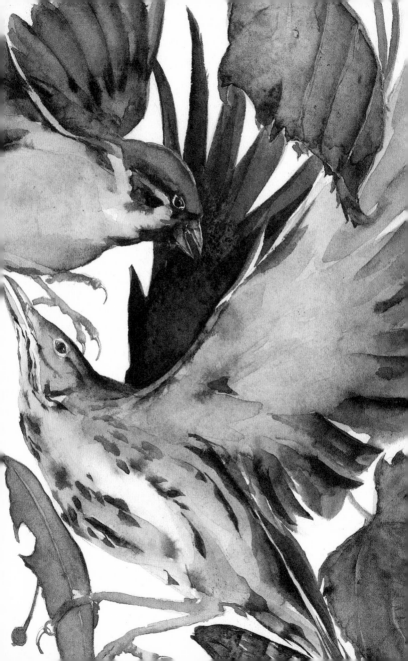

But my world takes years to grow and seconds
 to crash;
Your saw can fell me, your axe can bring me low.

Do you hear these words I utter? I ask this –
Have you heartwood, cutter? Have those
 who sent you?

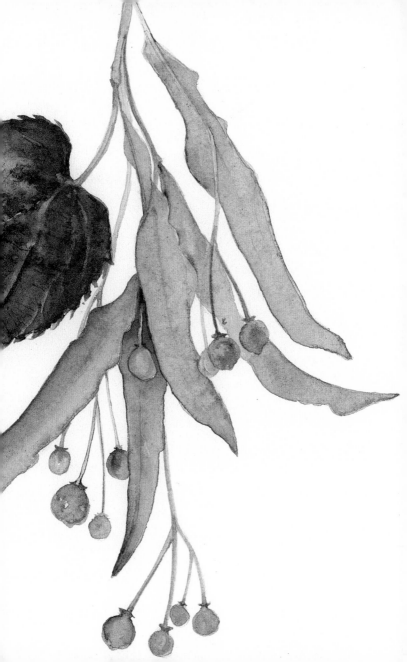

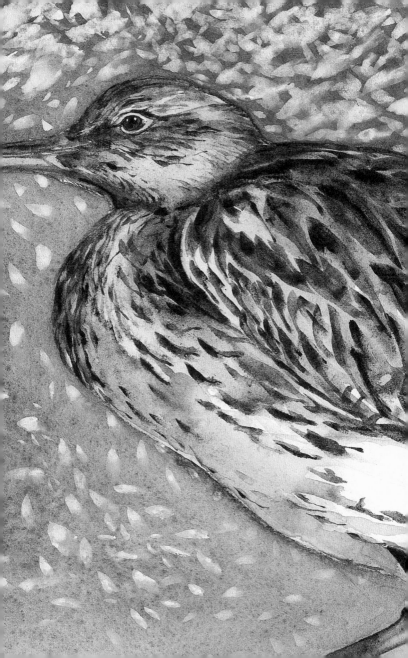

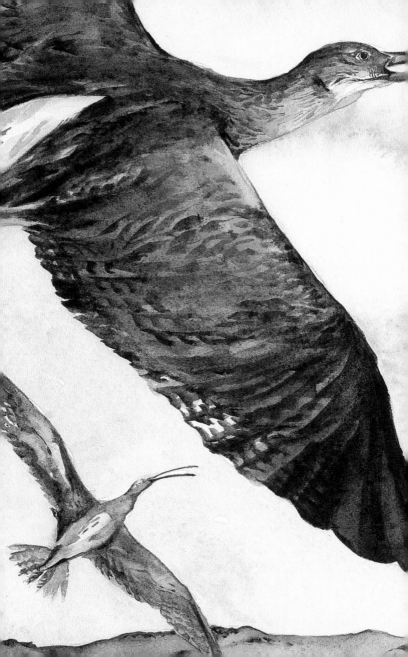

curlew

Curlew of the curved bill, winter-bringer, your
cry carries clear over corrie, fell and year;

Unearthly song of an eerie singer –
a bubbling spring, a wild bell-ringer,

Rippling out across lonely tops and sodden
ground; bird of snow, bird of sedge.

Low burns the wick now, close draws the edge;
I am old and slow and soon for sleep.

Each time I hear a Curlew call, though,
the world is sudden with wonder again.

Will you, Curlew, let me fall and come to rest
where your cry echoes off the hill?

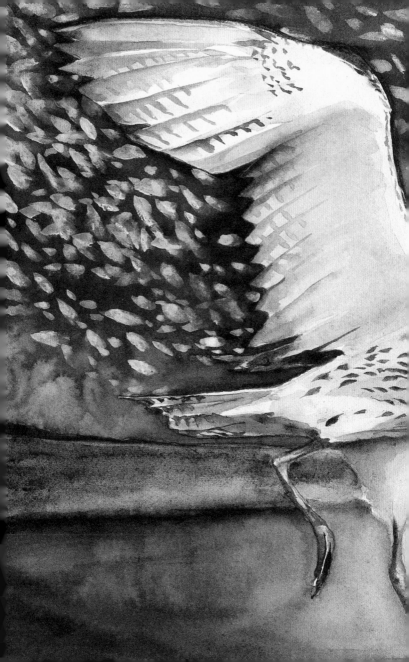

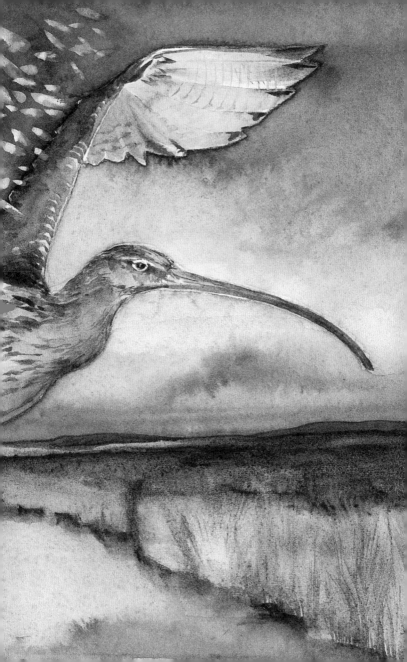

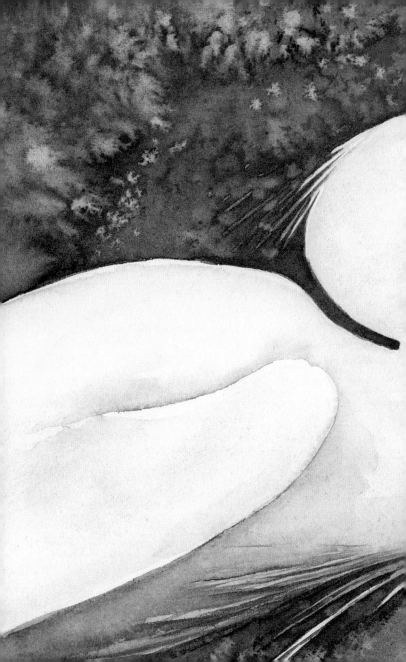

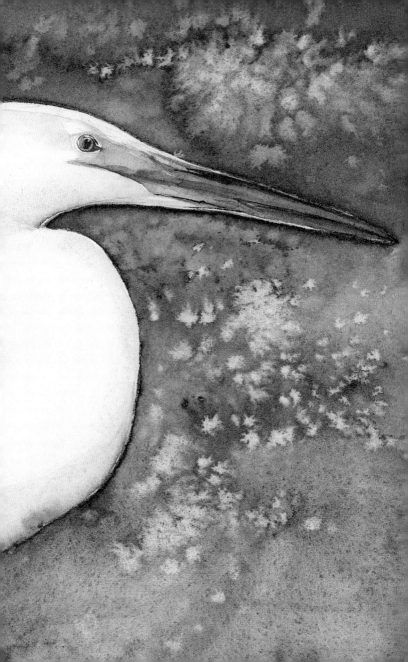

egret

Ever seen a brighter sight than
 Little Egret taking flight?

God damn you if you say you have!

Rip of paper, blaze of light; none
 quite matches Egret's white.

Egret out-gleams ice, out-flares
 dynamite and meteorite.

Twilight grows but Egret flies on,
 calm and low of height, scattering
 night to left and right.

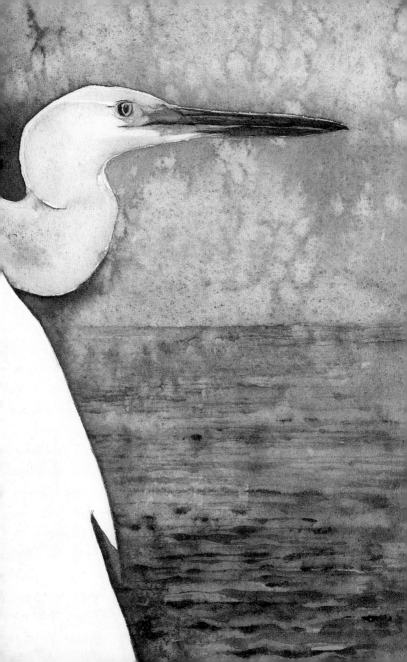

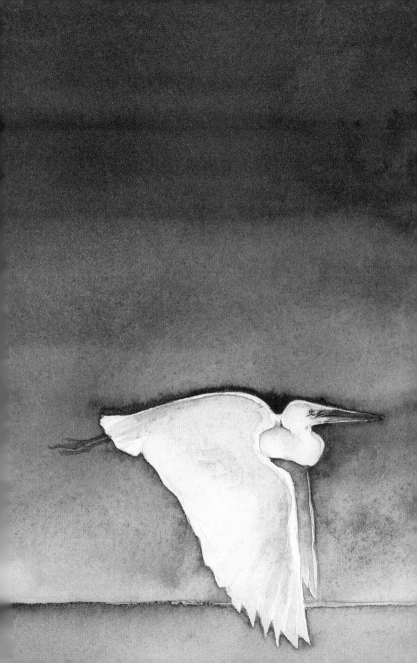

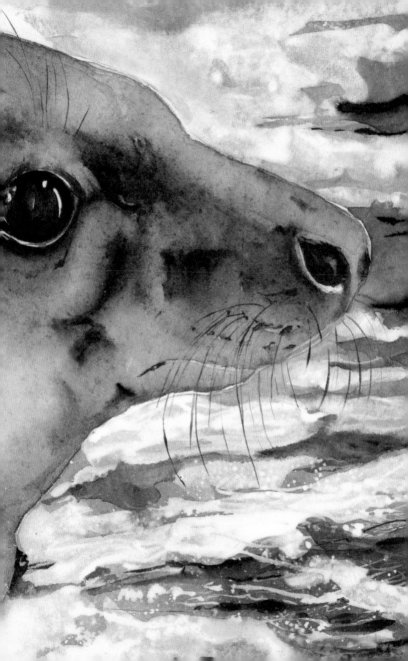

grey seal

Go now, Selkie-boy, swim from the shore,

Rinse your ears clean of human chatter,

Empty your bones of heather and moor,

Your skull of its human matter.

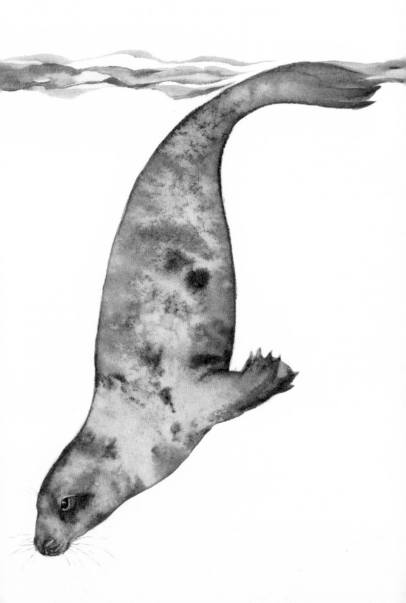

Slick is the rock where the waves wash the skerries,
Quick are the birds on the teeth of the reef,
Blue is the water that beckons, that buries,
Deep fall the fathoms beyond your belief.

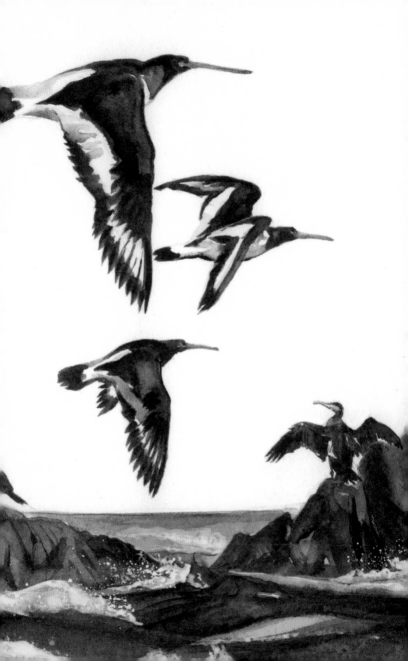

Selkie-boy, Selkie-boy, come join your kin,

Eager your kind are to meet you,

As salt sets its seal on your silky skin,

Let green sea rise up to greet you.

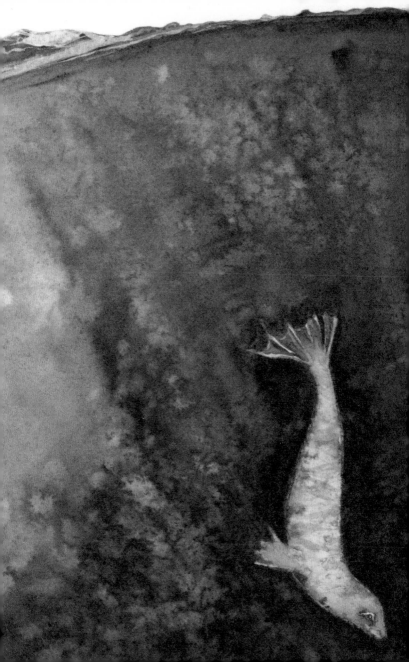

Hear us and hasten, O sweet Selkie-boy,
High are our voices lifted in song,
Offering welcome, keening our joy,
Drawing you down to where you belong.

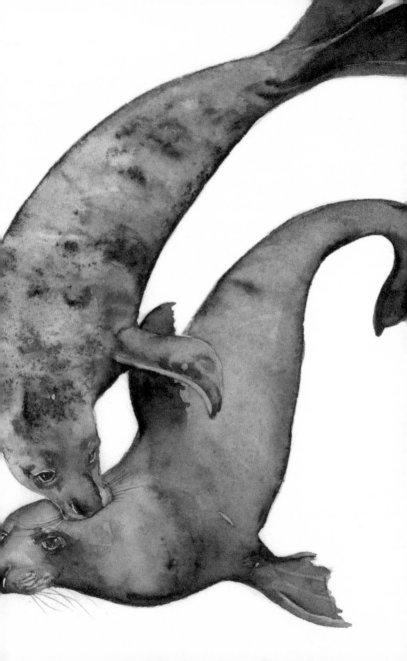

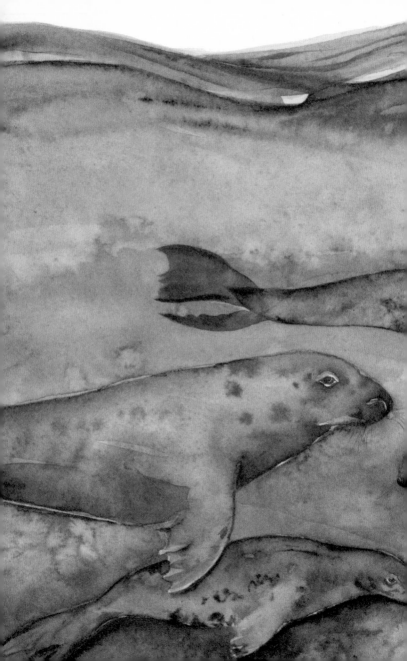

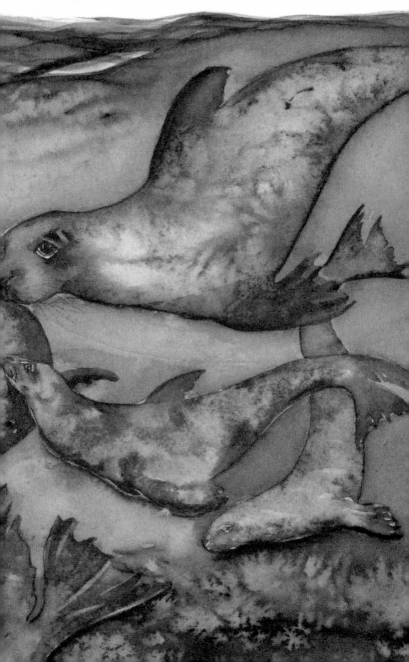

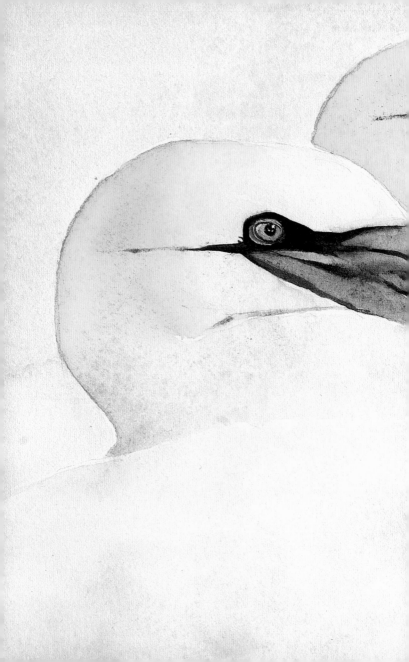

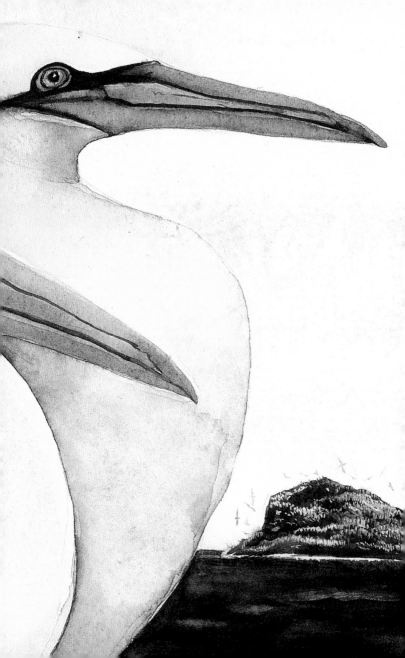

gannet

Gannet glides – stiff-winged, sharp-eyed –
 past cliff and stack;

A perfect paper aeroplane; all angles,
 creases, points.

Next moment without warning Gannet
 hinges, folds, *plunges* into calm sea;

Now – by Gannet origami – aeroplane is
 missile, rocket, ocean-splitter;

Electric bolt that shatters water, granite,
 earthly matter,

Torpedoing through bedrock, mantle, core,
 to surface elsewhere on the planet.

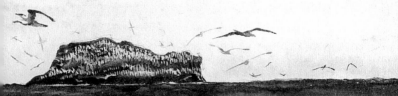

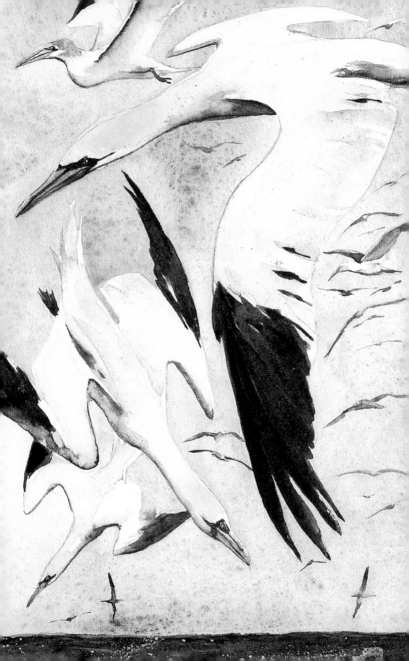

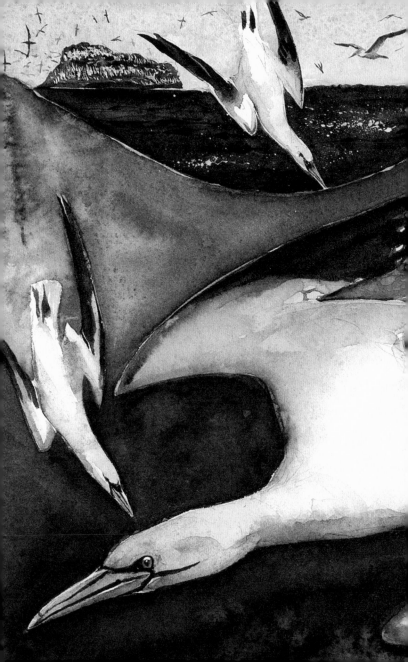

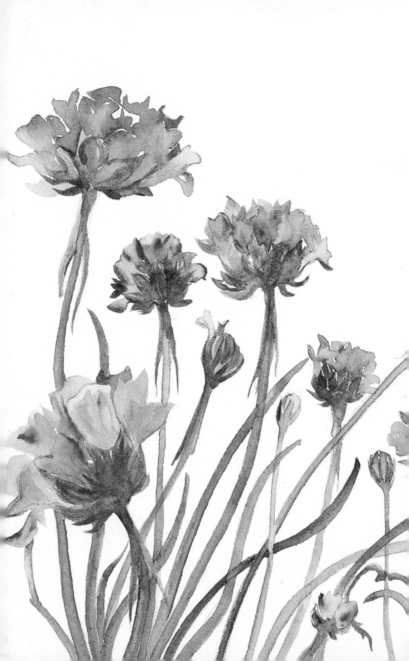

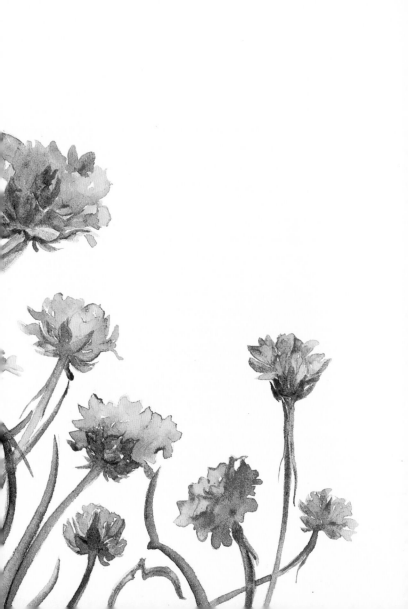

thrift

Thrift thrives where most life fails, falls,
 is cast adrift.

High on mountain ridges, sea-cliff ledges,
 island edges, Thrift resists, survives –
 flower of brinks and rifts, veteran of sheer
 drops and near misses, queen of *in extremis*,
 planting pink-as-candy lipstick kisses on
 basalt columns, granite outcrops.

Raven lifts, tumbles; falcon shifts, soars,
 plummets; storm rumbles, wave sifts, moor
 burns, crag crumbles – so time turns and
 turns again, so time's song sings on and
 on, and all the while humble Thrift just
 grafts along.

In saltmarsh, dune, moraine – where
 going's rough and margin's fine –
 Thrift digs in, growing quietly on
 through drought and rain.

Far above the rock-pools and the beaches,
 Thrift clings on; a lighthouse keeper
 for every weather, a seaside saint in
 her clifftop niches.

Thrift blooms on spoil-heap and tailing,
 for Thrift knows hardship is a limit not
 a failing; Thrift persists despite all odds,
 and Thrift's gift is – Thrift's grace is –
 to give a glimpse of hope in the tightest
 of spots, the toughest of places.

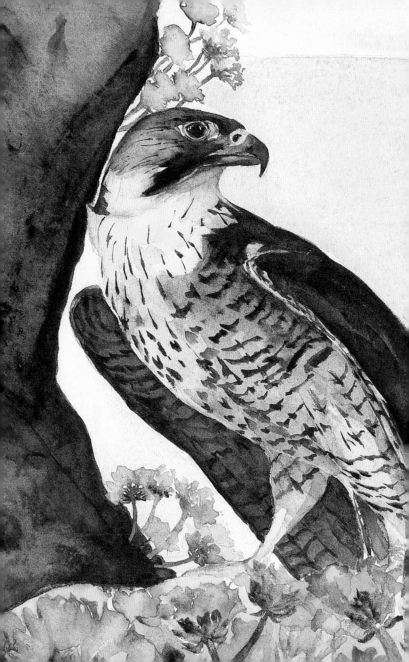

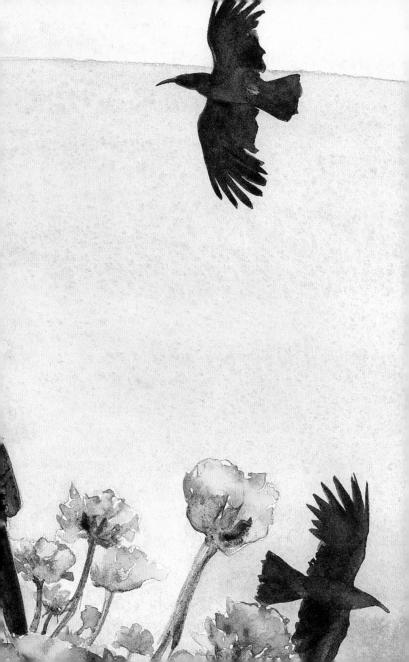

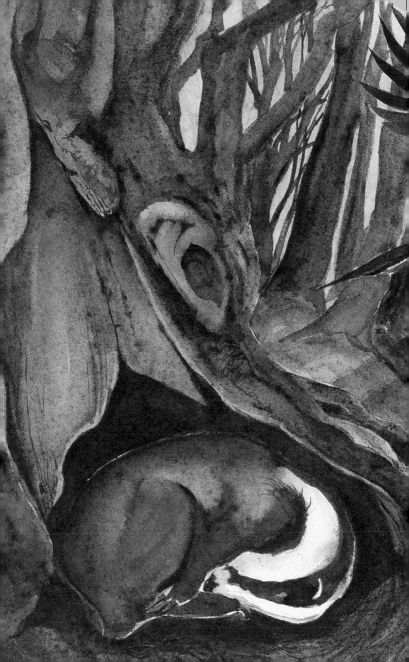

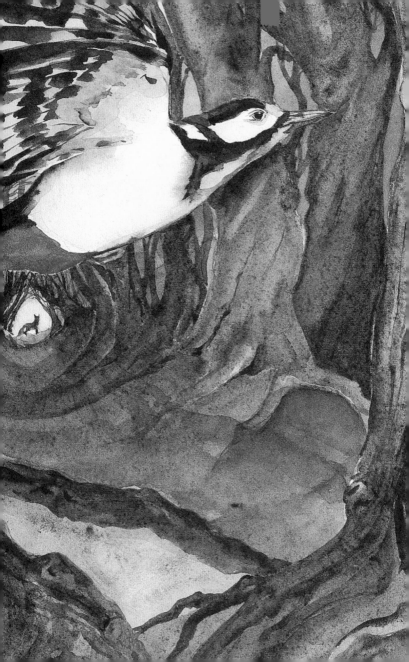

woodpecker

Woodpecker, tree-wrecker, would you ever give your neck a rest and let a fellow get a bit of peace round here?

Oh no, very sorry, but I'm far too busy; got to check a beech, a hazel and an ash for beetles, larvae, weevils; I have things to do, my friend; goodbye – must fly!

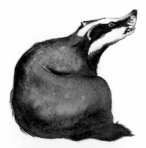

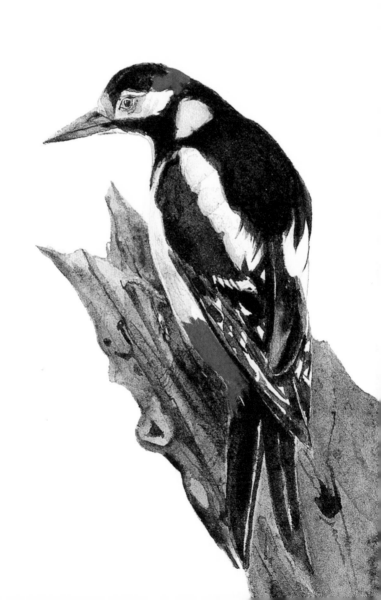

Over-worker, why not shirk a tree or
 three; you've surely earned the right
 to take a break from making holes all
 day and night?

Don't concern yourself on my behalf;
 I'm fine and dandy, thank you kindly,
 and my modus operandi is to drill until
 I fill my bill with insect candy.

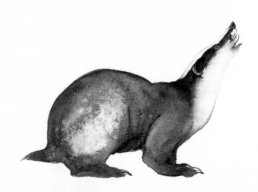

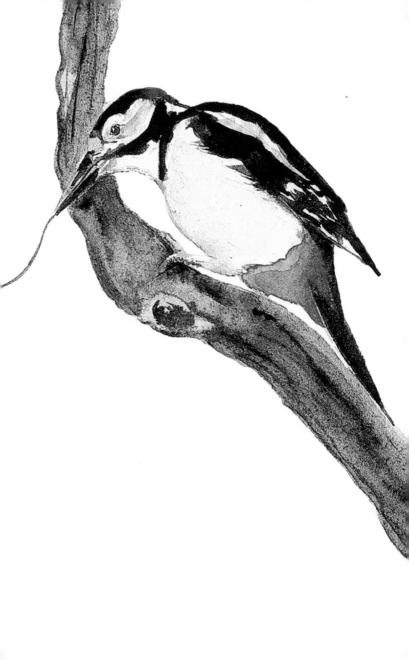

Press pause! Chill out! Relax a while!
Take up a hobby maybe (just not
the drums or carpentry . . .)?

*Ever thought that maybe I just like to
live my life staccato, love to be the
forest's castanet; swooping round from
crown to crown in my tuxedo, tapping
out my Morse-code alphabet?*

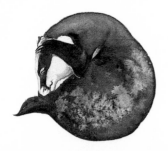

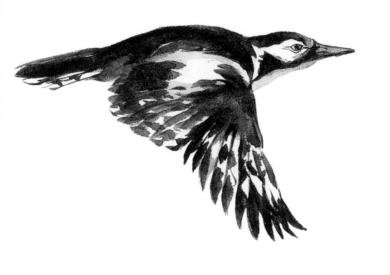

Chisel-gouger, head-banger, bark-stripper, grub-picker, nerve-shredder ... the kicker, Mister Woodpecker, is you're boring me to death!

Kindly cease your castigation; boring is my occupation – setting up reverberation from amid the vegetation is to me not aberration but a sweet intoxication!

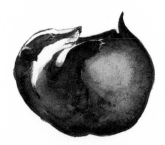

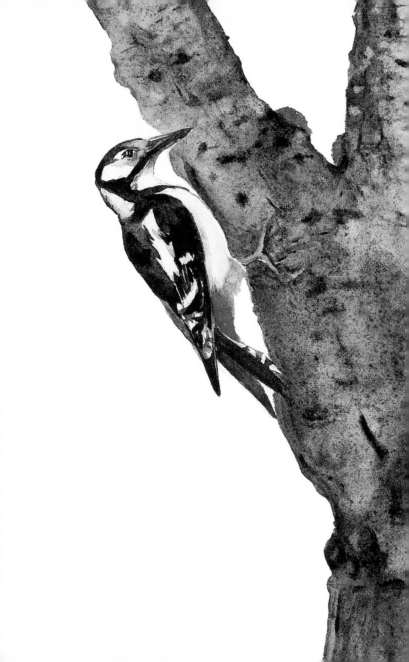

Each and every excavation doubles up
 my irritation, expedites deforestation;
 save us all some enervation, undertake
 a transformation – quit your tunnelling
 fixation!

Remedy the situation, get yourself
 some ear protection – for I abhor
 procrastination, must perfect my
 perforations, put my skull in oscillation,
 sending out my good vibrations all
 throughout our forest nations!

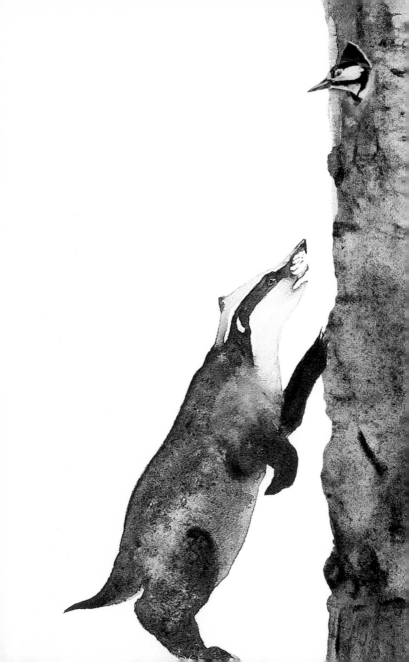

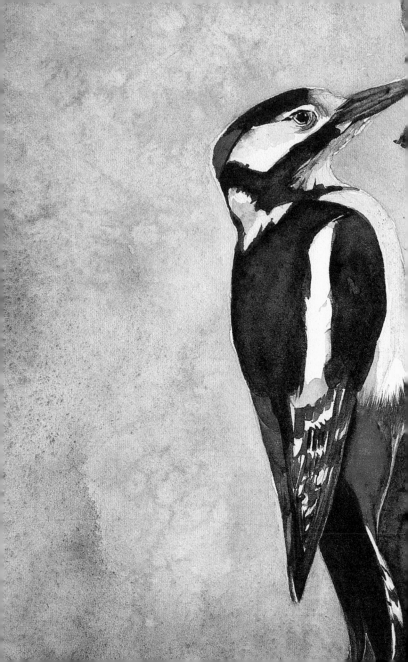

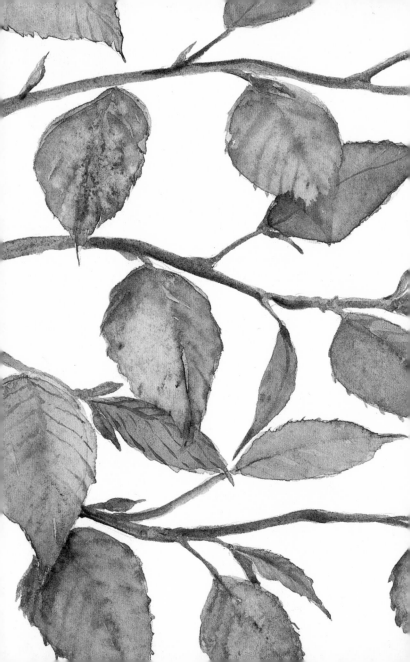

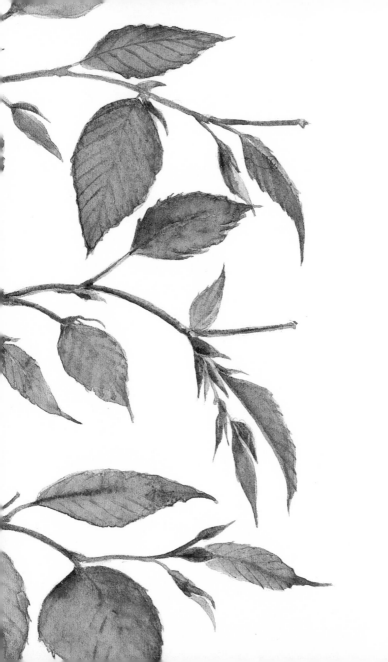

beech

Beech gives wind speech –

Each branch reaches to other
branches as the gale rises;

Each leaf dances with other
leaves as the storm crashes.

Can you hear that inland sea,
its slow explosion?

High in the hill-woods, huge
surf breaks far from any ocean.

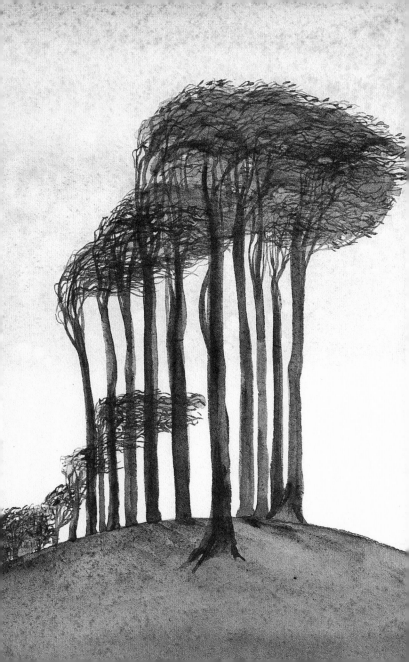

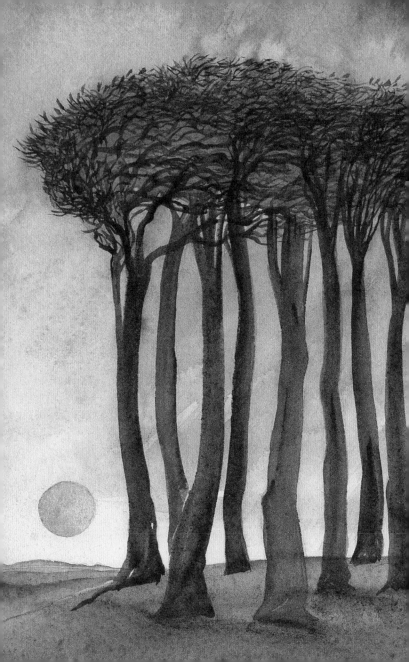

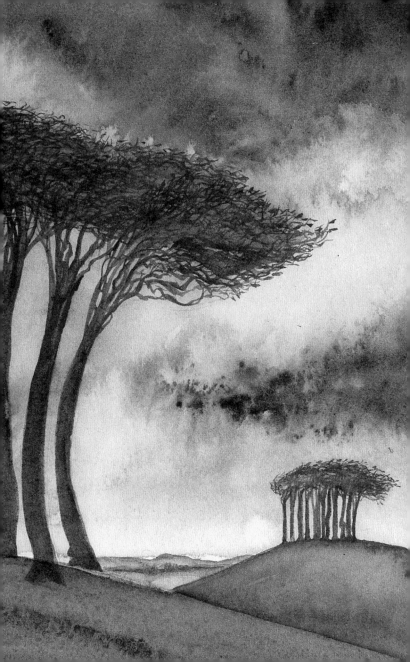

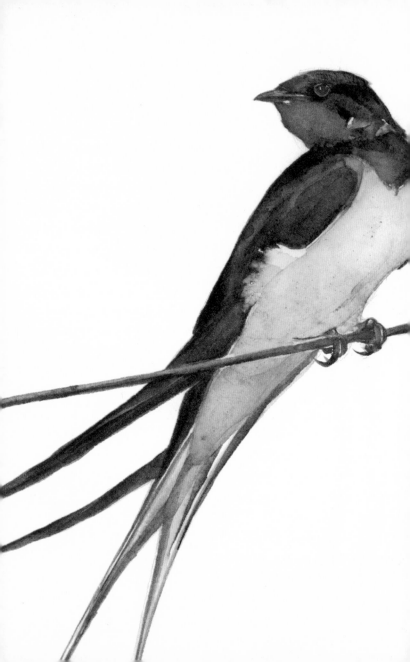

swallow

Soft this evening I lay listening to my
 child breathing slow and shallow in
 the darkness of her sleep,

When without warning I fell deep into the
 gap that opened up between her breaths.

All the world was halted in that cold,
 steep-sided space; the stars un-shining,
 sun un-dawning, trees un-growing,
 birds transfixed mid-air, mid-song.

Light failed, heart lurched, colour fled,
 grief beckoned;

Life, dear life, suspended in that second
 for an age –

Only saved when you flew low into the
 shadow, Swallow, streamers flowing,
 closing up that chasm with your
 swooping, sewing flight!

With a stroke the stars renewed their
 burning in the black, the sun its
 turning, trees their leafing, birds
 their singing, she breathed in again
 and life poured back.

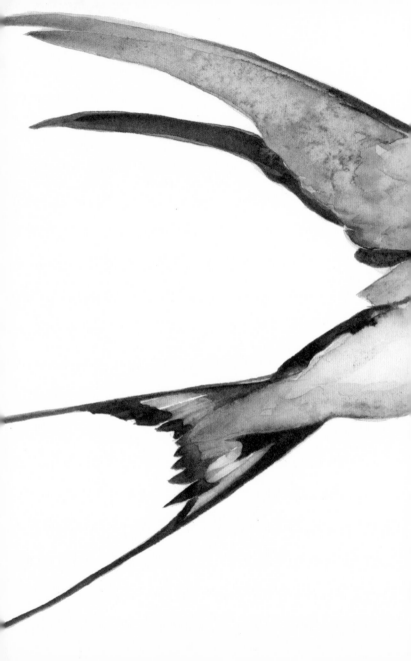

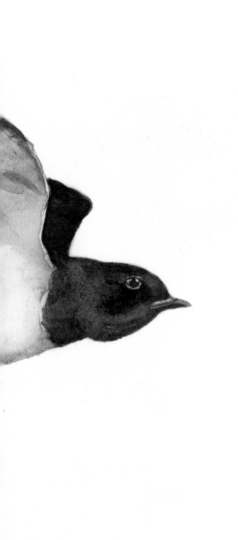

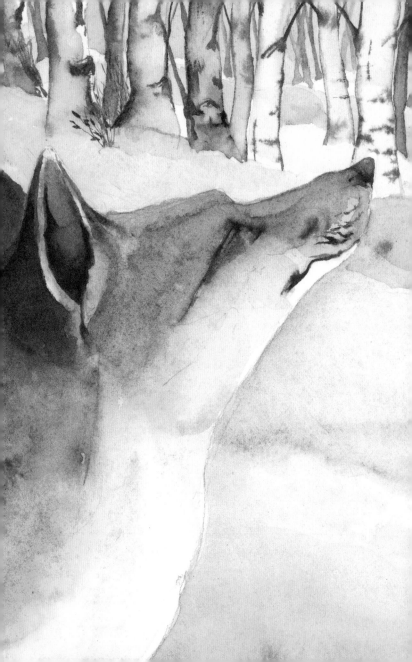

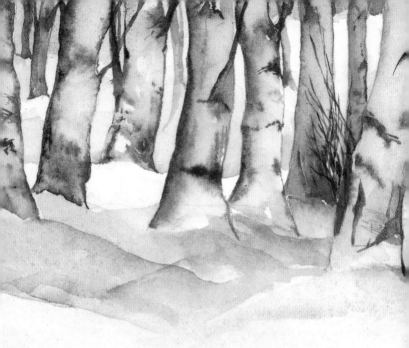

silver birch

a lullaby

Snow is falling, my silver-seeker;
soon the path will be lost to sight,
soon the day, the day will give way to night –

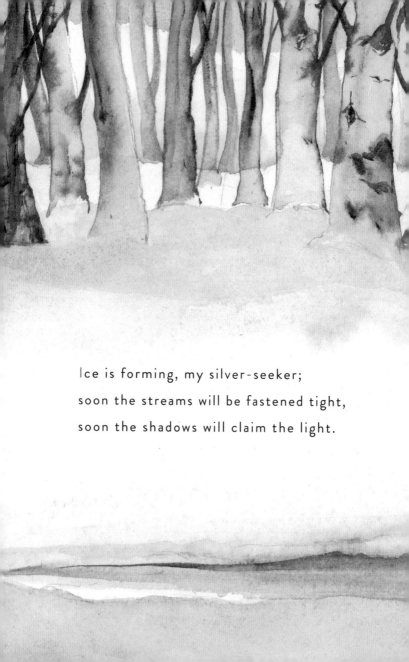

Ice is forming, my silver-seeker;
soon the streams will be fastened tight,
soon the shadows will claim the light.

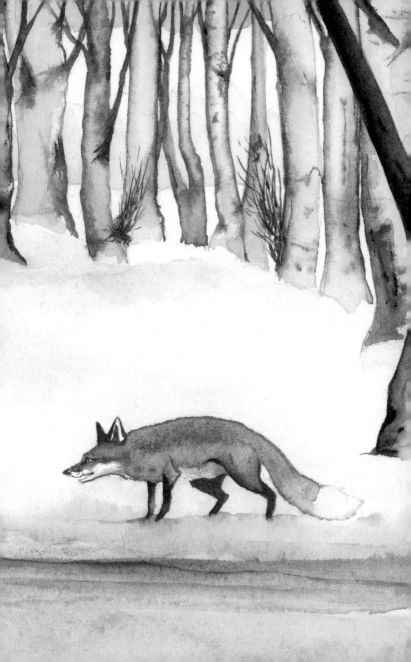

Look over your shoulder at where you have been;
the edge of the wood can no longer be seen –

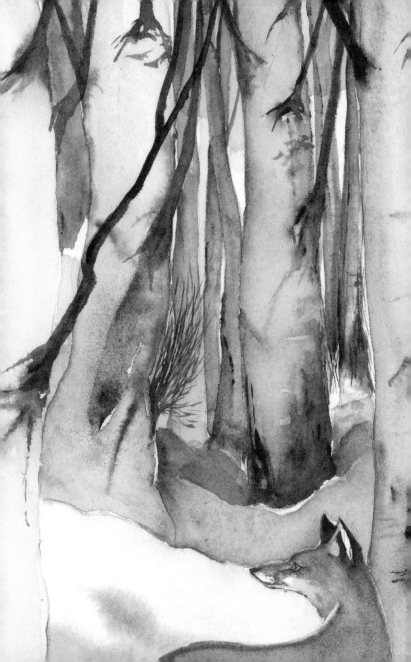

Vast is the forest and slender your track;
harder it grows to find your way back.

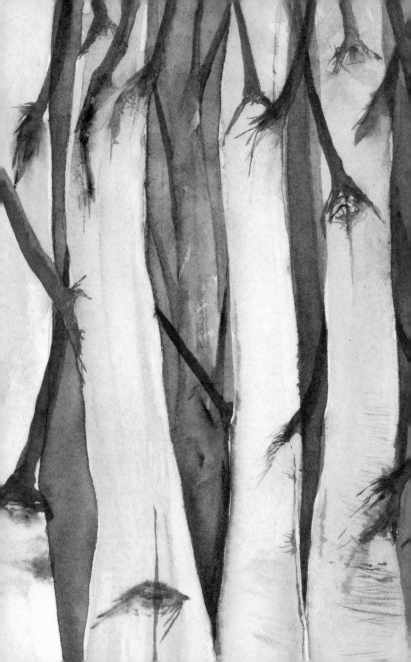

Even as the dusk gets dimmer,

still the birch trunks glow like torches,

still the birch-bark holds its glimmer.

Rest your head now, silver-seeker;
close your eyes and cease your searches
where the blackbird brightly perches,
where the catkin softly brushes,
here among the gleaming birches.

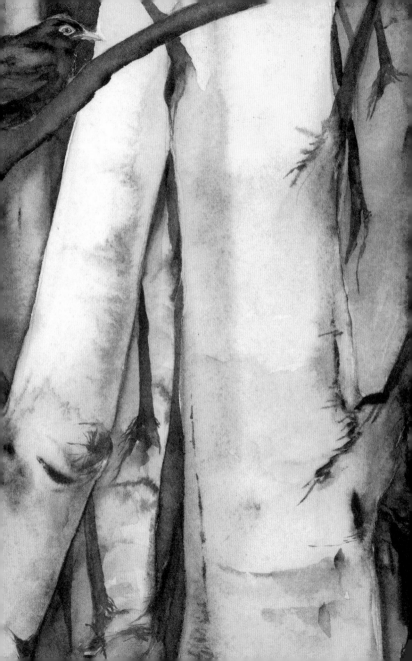

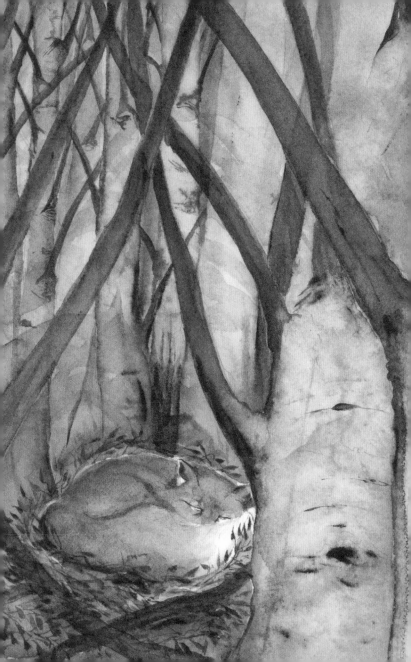

Break of dawn is far away

but you are safe, my silver-sleeper,

safe to sink down deep and deeper;

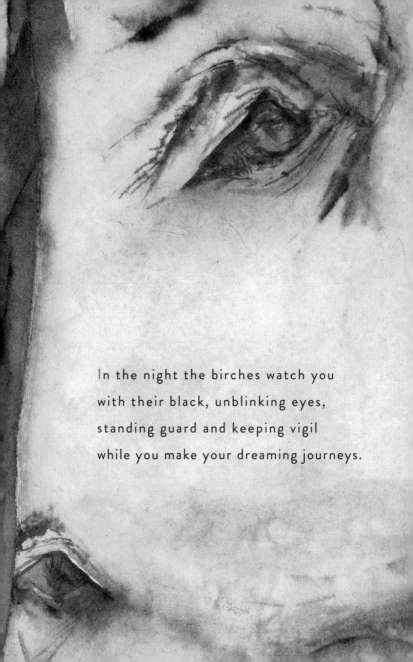

In the night the birches watch you
with their black, unblinking eyes,
standing guard and keeping vigil
while you make your dreaming journeys.

Round and round the dangers prowl
– wolves and monsters, worries, witches –
but the birches stand like churches
as the dark around them surges,

Circles, crouches, clutches, lunges –
but breaks its power on birches' branches,

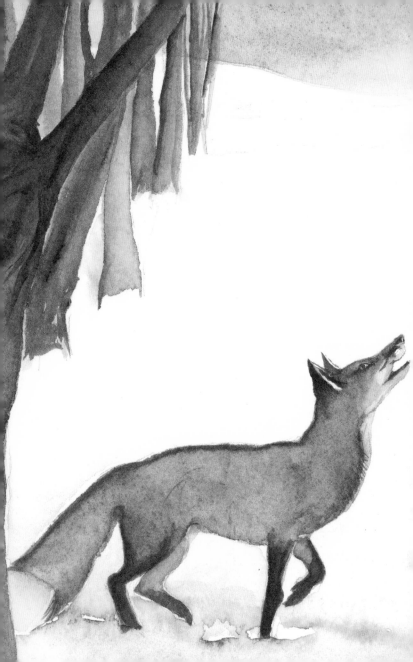

Held at bay until at last the sun emerges,
warms the pines, the larches,
lights your yawns, your stretches,
there among the silver birches.

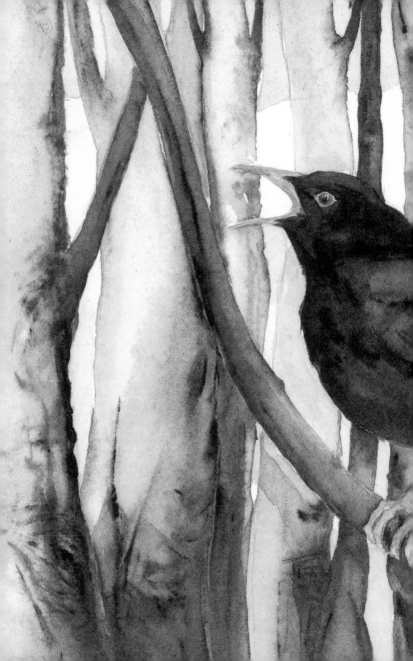

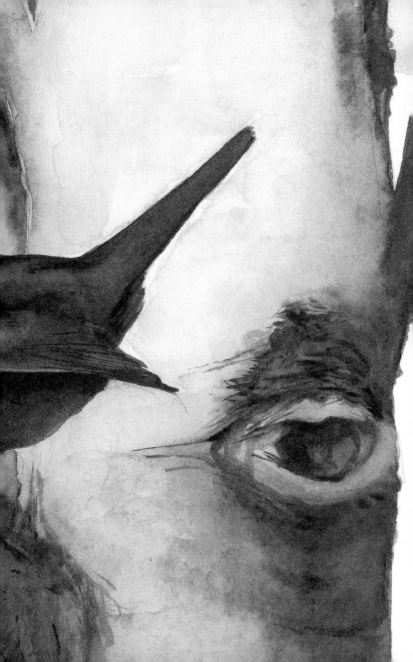

glossary

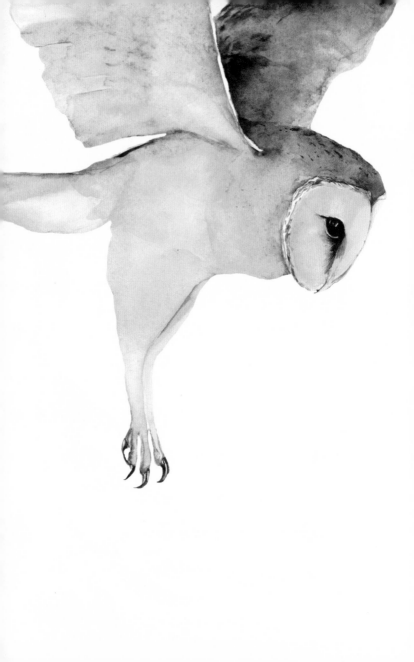

Here is *The Lost Spells* glossary, at once a puzzle and a key. Seek each flower and insect in these pages, speak each creature, find each tree. Then take this book to wood and river, coast and forest, park and garden; use it there to look, to name, to see.

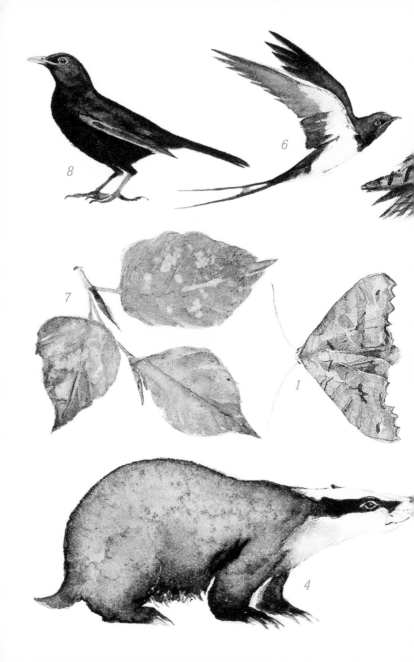

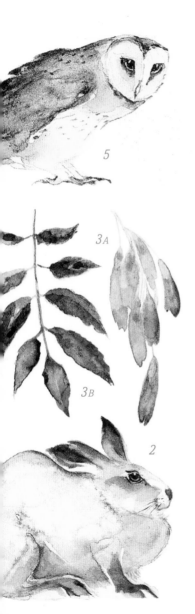

1. **Angle Shade** Moth
 Phlogophora meticulosa

2. Snow Hare
 Lepus timidus

3. **Ash**
 Fraxinus excelsior

4. **Badger**
 Meles meles

5. Barn Owl
 Tyto alba

6. **Barn** Swallow
 Hirundo rustica

7. Beech
 Fagus sylvatica

8. **Blackbird**
 Turdus merula

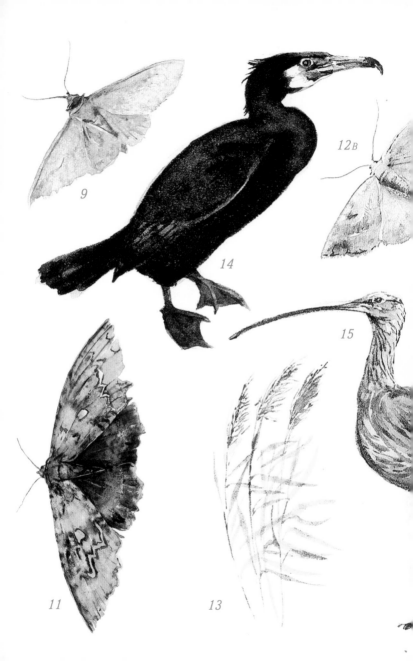

9

12в

14

15

11

13

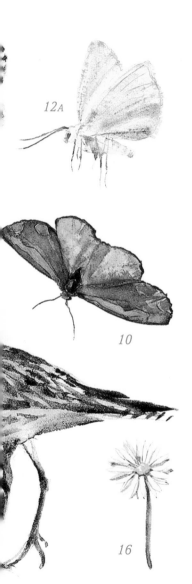

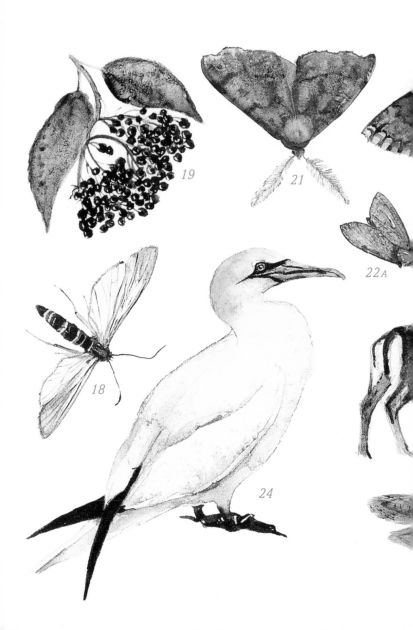

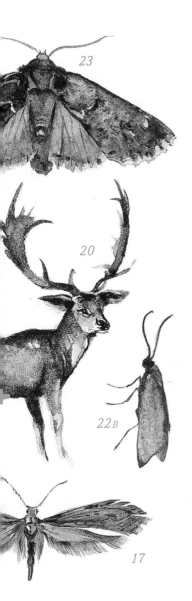

17. **Diamond-Back** Moth
 Plutella xylostella

18. **Dusky Clearwing**
 Paranthrene tabaniformis

19. **Elder**
 Sambucus nigra

20. **Fallow Deer**
 Dama dama

21. **Feathered Thorn** Moth
 Colotois pennaria

22. **Forester** Moth
 Adscita statices

23. **Frosted Green** Moth
 Polyploca ridens

24. Gannet
 Morus bassanus

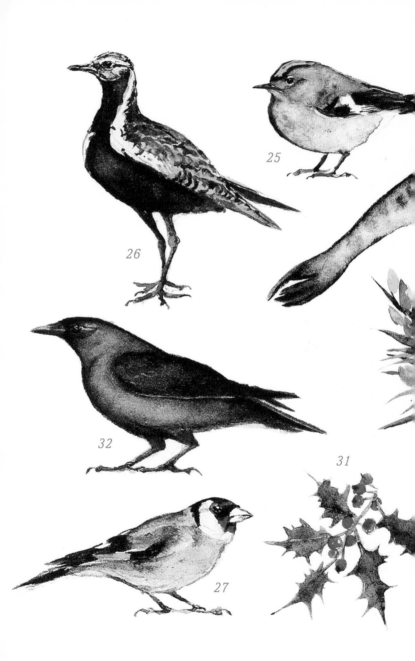

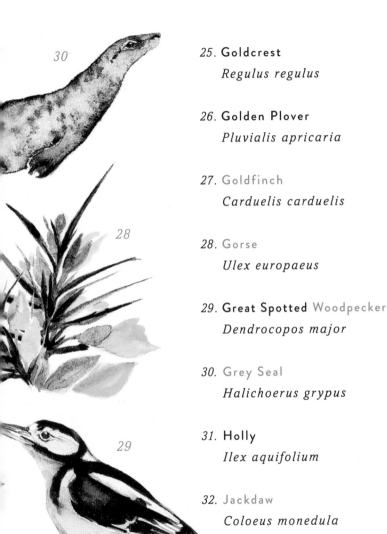

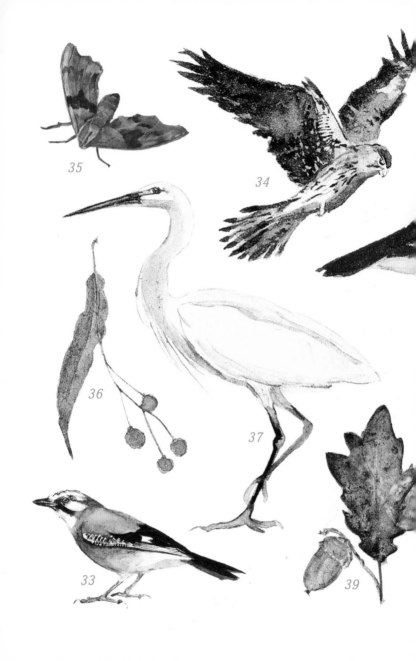

35

34

36

37

33

39

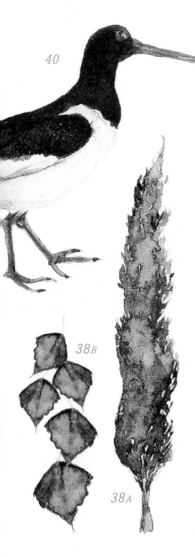

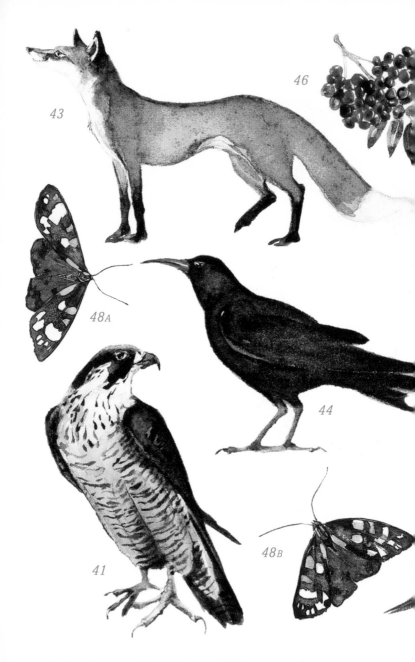

43

46

48A

44

41

48B

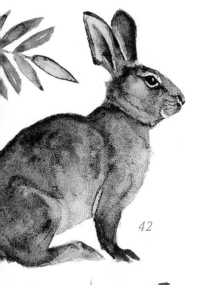

42

47

45

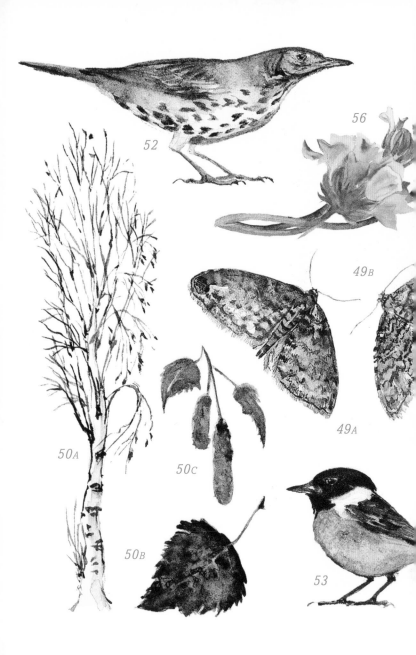

52

56

49B

50A

50C

49A

50B

53

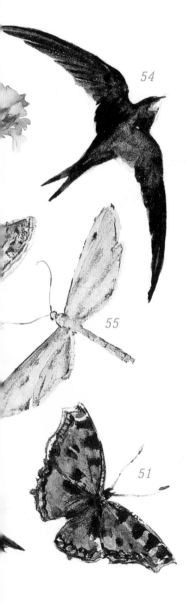

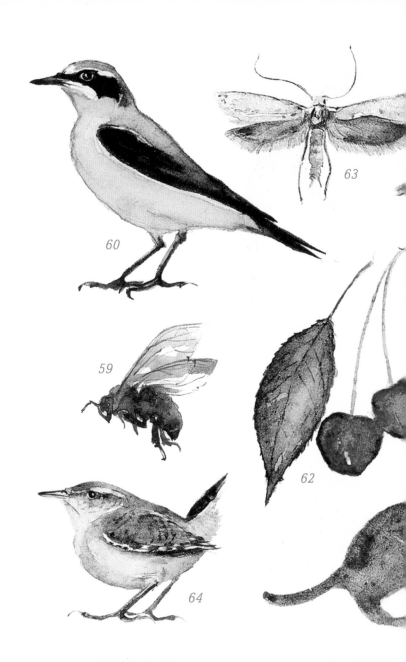

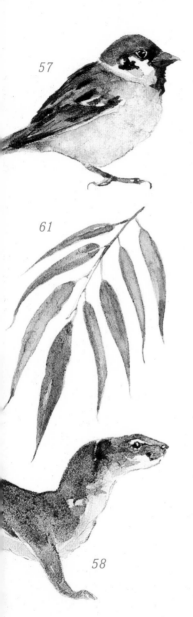

57. **Tree Sparrow**
 Passer montanus

58. **Weasel**
 Mustela nivalis

59. **Welsh Black Bee**
 Apis melifera melifera

60. **Wheatear**
 Oenanthe oenanthe

61. **White Willow**
 Salix alba

62. **Wild Cherry**
 Prunus avium

63. **Willow Ermine** Moth
 Yponomeuta rorrella

64. **Wren**
 Troglodytes troglodytes

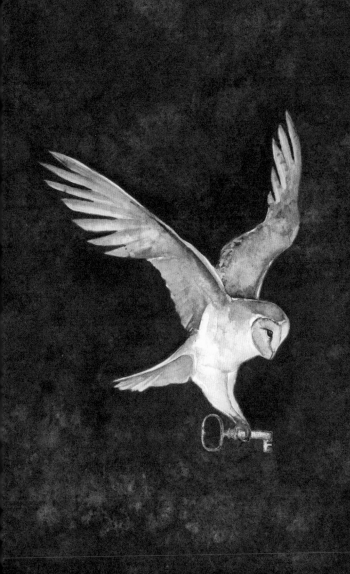

First published in the United Kingdom in 2020 by Hamish Hamilton,
part of the Penguin Random House group of companies
First published in Canada in 2020 and the USA in 2020
by House of Anansi Press Inc.
www.houseofanansi.com

25 24 23 22 21 2 3 4 5 6

Library and Archives Canada Cataloguing in Publication

Title: The lost spells / Robert Macfarlane, Jackie Morris.
Names: Macfarlane, Robert, 1976– author. | Morris, Jackie, illustrator.
Description: Illustrated by Jackie Morris.
Identifiers: Canadiana 20200207709 |
ISBN 9781487007799 (hardcover)
Subjects: LCSH: Nature—Poetry. | LCSH: Nature in art.
Classification: LCC PR6113.A23 L67 2020 | DDC 821/.92—dc23

Designed by Alison O'Toole
Colour reproduction by Rhapsody Ltd

Canada Council Conseil des Arts
for the Arts du Canada

ONTARIO ARTS COUNCIL
CONSEIL DES ARTS DE L'ONTARIO
an Ontario government agency
un organisme du gouvernement de l'Ontario

We acknowledge for their financial support of our publishing program
the Canada Council for the Arts, the Ontario Arts Council,
and the Government of Canada.

Printed in Italy by Printer Trento S.r.l.

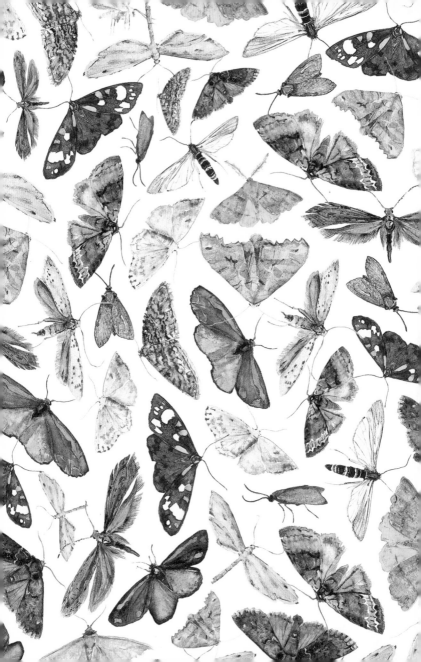